Frank Lloyd Wright

Trewin Copplestone

GRAMERCY

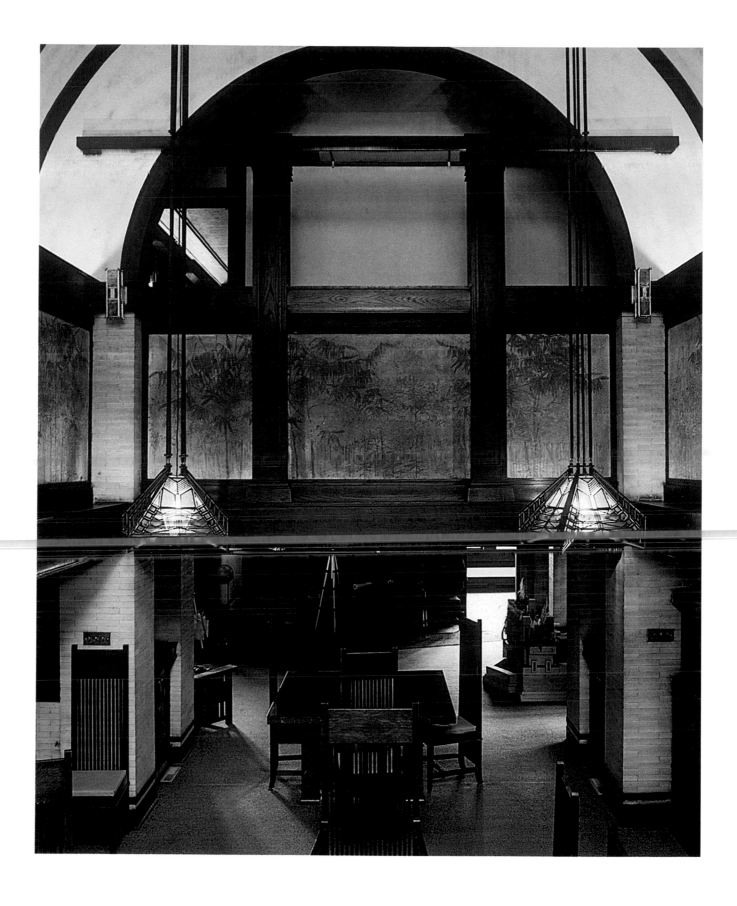

This 1999 edition is published by Gramercy Books™, an imprint of Random House Value Publishing, Inc., 201 East 50th Street, New York, NY 10022

Gramercy Books ™ and design are trademarks of Random House Value Publishing, Inc.

Random House New York • Toronto • London • Sydney • Auckland
http://www.randomhouse.com/

Printed in Singapore

ISBN 0-517-16115-X

10 9 8 7 6 5 4 3 2 1

List of Plates

PLATE 1

Frank Lloyd Wright studio plaque.

Frank Lloyd Wright was the most significant native-born American architect of this century. This somewhat guarded claim would not have satisfied Wright himself; indeed it would probably have irritated him intensely as he not infrequently claimed to be the greatest architect who had ever lived. Certainly he considered himself, and with some justification, to be the most important architect of his time and the truth probably lies somewhere within the range of both these judgements. In any event, it is certainly desirable that any architect, intent on launching a successful career, is able to persuade potential clients that he is the best available and the candidate most likely to be able to fulfil their requirements. Architecture is a profession which depends largely on conviction in advance of proof and the provision of financial resources before the end result becomes finally apparent. What the architect in fact sells are ideas, presented in the form of drawings and/or models: the building itself cannot be constructed in sample form as, for instance, a chair or a detergent, in order to prove its effectiveness in advance. The qualities of an architect must, in the first instance, be taken on trust; if he does not believe in himself he is unlikely to be able to convince others.

Wright suffered no such inhibitions in this respect, being the possessor of a high degree of self-belief. Such confidence is indeed not unusual; but it is much less usual to find it fully vindicated in action. It is an important factor in Wright's life that, despite an extraordinarily varied career,

sometimes bizarre, sometimes tragic, always unusual and frequently unpredictable, his work should from the beginning show an originality and creative intelligence that few possess and even fewer have been as convincingly able to demonstrate.

It is, of course, such qualities as these that are essential to genius in any sphere of human endeavour and architecture is one of the most complicated and demanding in arriving at satisfactory, much less inspiring, solutions. It holds a unique position in the so-called fine arts – sometimes described as the 'Mother of the Arts' – in that it is the only one which is indispensable to any developed society. Every civilization is partly defined and recognized by its architecture and throughout history individual architects have contributed largely to the quality of life within their own societies. It is important, therefore, in view of the subject of this book, to give some consideration to the nature of that contribution.

Architects must reconcile two demands which are not always compatible. On the one hand, they must construct a stable functioning structure involving technical expertise combined with an intimate knowledge of different materials and methods – what might be described as the science of structure. On the other hand, they must be able to construct a three-dimensional object imbued with pleasing characteristics, visual satisfactions that will appeal to the users but which in themselves are of little or no essentially

PLATE 2

Frank Lloyd Wright's Own House and Studio, Oak Park, Chicago, Illinois
1889–1909

Houses designed by architects for themselves offer a freedom of treatment not usually present in projects for clients and are, in consequence, often the most rewarding. With this early building, which Wright worked on and modified over a period of nearly ten years as his family and practice increased in size, we have the opportunity to observe the development of his personal aesthetic. Starting with a small house, he enlarged it to include an attached studio with an octagonal library and a two-storey draughting room

with a suspended balcony, as well as a new dining room and a playroom. His use of sculpture and decorative objects are apparent with such additions as works by Richard Bock (commissioned for his decorative sculpture by Wright over many years), and heavy stone flower urns of Wright's own design which became a feature of many of his later houses. The house was open-plan and the furniture and decorative panels were also designed by Wright. The fireplace in the main living room is in the form of a Romanesque arch, popularized by Richardson and elaborated by Sullivan. One feature of the house which became a centrally identifying feature of psychological importance is the fireplace/hearth, which Wright continued to place at the core of his domestic buildings. It attempts to focus the hearth as the heart of the home.

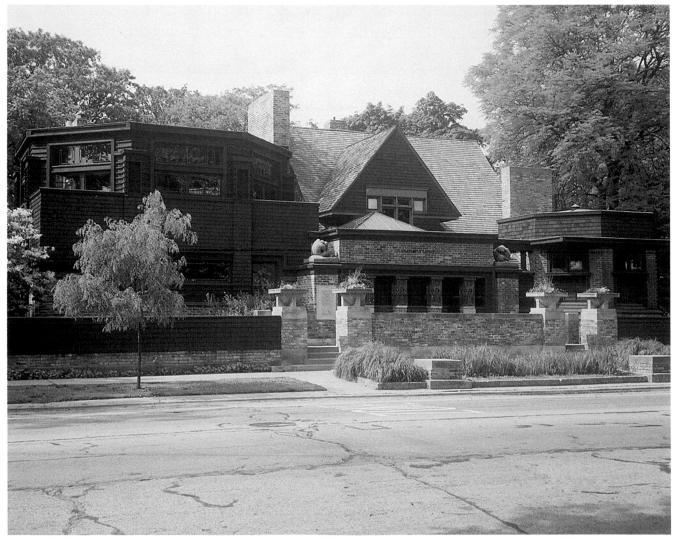

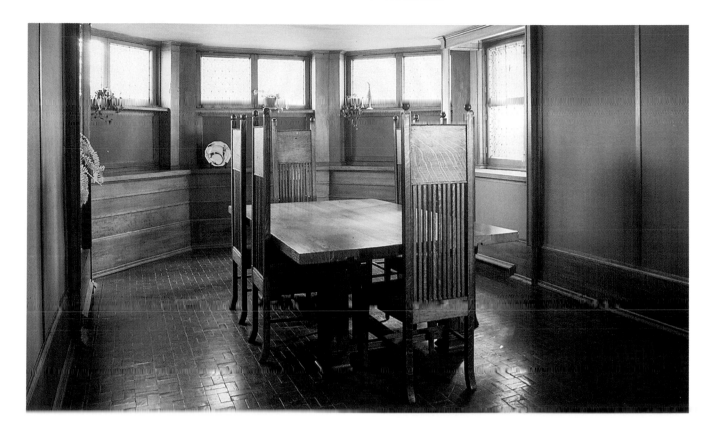

practical use. (This is the artistic or, more formally, the aesthetic dimension.)

The subject of aesthetics is difficult to quantify, even though it encroaches into so many areas of human life. It is concerned with the abstract, degrees of beauty and ugliness, of satisfaction of the senses, of attraction and repulsion. When the particular object is a painting, a sculpture or a piece of music, it is possible to either enjoy it or to simply walk away. With architecture this is not so. It stands there, a large lump of usefulness, be it visually and emotionally satisfying or otherwise. What makes the difference is not usually its practical effectiveness, which may now usually be assumed, but the qualities that makes it art — its aesthetic dimension.

In brief, architecture is a technically efficient art. It will therefore be apparent that creating architecture is a tough assignment at all times, and especially for those architects who have genuine ambitions to providing an aesthetically satisfying, structurally sound and functionally effective solution. It has to be admitted that most architecture falls short of these criteria, relying on precedent, ignorance or fear; but for the few, it is the artistic element that is the most difficult and important, particularly at this time when there are so many other professionals ready to assist the architect in the technical elements of his/her work.

Originality in architecture is the creative aesthetic element. In this, as the reader will probably already have

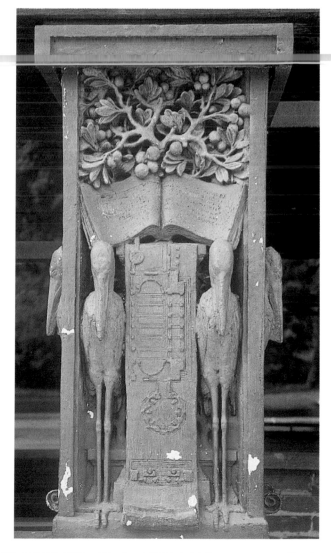

PLATES 3 and 4 opposite and below

Frank Lloyd Wright's Own House and Studio, Oak Park, Chicago, Illinois
1889–1909

As the Lloyd Wright family became larger, it was necessary to build a bigger dining room, the original dining room becoming the children's playroom. Below: One of four columns designed to form an imposing and decorative entrance to the house.

PLATE 5 below

Francisco Terrace Apartments, 253–257 Francisco Avenue, Chicago, Illinois
1895. Demolished 1974, archway re-erected in Oak Park in 1977

The simple undecorated character of these low-cost apartments, designed with care in respect of proportion, are only elaborated by the Richardsonian archway reminiscent of Sullivan's Stock Exchange entrance arch being constructed at the same time. Wright was beginning to gain larger commissions and this was one of his first designs. The archway led into a rectangular courtyard with the apartments facing onto it. Only the apartments bordering Francisco Avenue were publicly visible and Wright was concerned to create a sense of community within the whole structure.

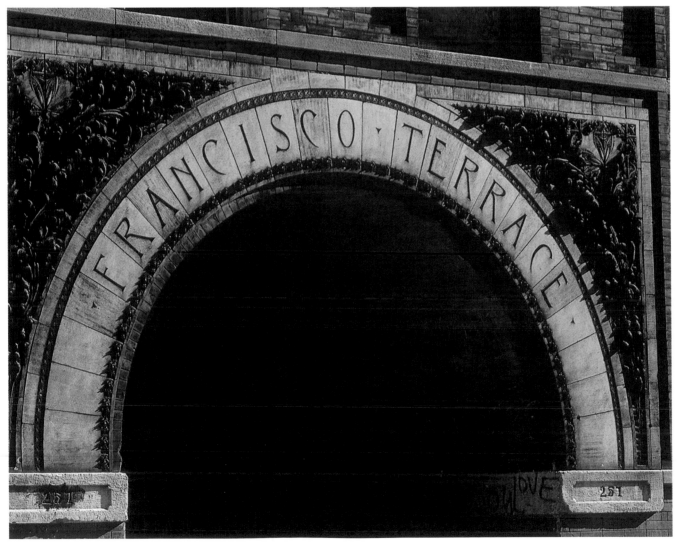

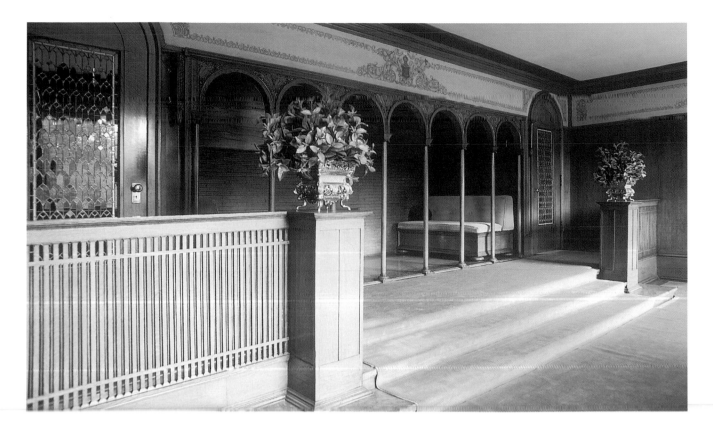

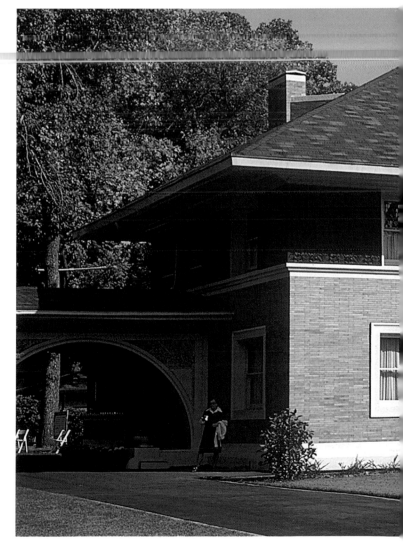

anticipated, Frank Lloyd Wright was a master for whom the aesthetic inspiration was the prime mover. Wright's own contention was that designing a house is like painting a portrait.

The historic and stylistic character of architecture in America had for obvious reasons originated in the prevailing European models of the time. Insofar as the first colonists had experience of architectural style, it would have been an awareness of Renaissance forms, developed from the original inspiration of the classical architecture of Greece and Rome, or from the architectural forms which emerged during the early growth of Christianity in the extraordinarily creative period known as the Medieval or the Middle Ages. It would be true to say that the character of European architecture derives from one or other of these two sources, or is a composite of the two for almost the whole course of its history. From the 16th century, when the extent of Eastern civilizations increasingly came to be discovered, there was some reflection of these sources in a number of exotic buildings; but they remained essentially a peripheral influence. It remains true that, from the 6th century B.C., the highest point of Greek culture, to the 19th century throughout Europe, a strength and creative energy existed that produced the styles that have dominated architectural history (invading even Eastern societies in turn) and which have provided the criteria by which the form of Western architectural quality has been established.

PLATES 6 and 7 opposite and below
William H. Winslow House, River Forest, Chicago, Illinois 1893

River Forest, like Oak Park and contiguous with it, was in the 1890s a suburb of Chicago and Wright extended his practice there. The Winslow house was the first of Wright's independent commissions after leaving Sullivan and is a bold statement of his ideas at the time. Its most obvious feature is the heavy roof form and overhanging eaves, tying the house to terra firma, and established by the low platform on which the whole structure is

placed, while the terracotta frieze beneath the eaves enhances the horizontal effect. The simple symmetrical front elevation, with its fine Roman brickwork emphasizing the white features of doorway and windows, contrasts with the elaborated asymmetrical rear, approached through the porte cochère *on the left, which is in the form of the simplified Romanesque semi-circle. At the rear, the stair tower and the dining room bay enliven the design which has a much less controlled, more traditional aspect, and provides the opportunity for solving awkward necessities, such as servants' quarters and services.*

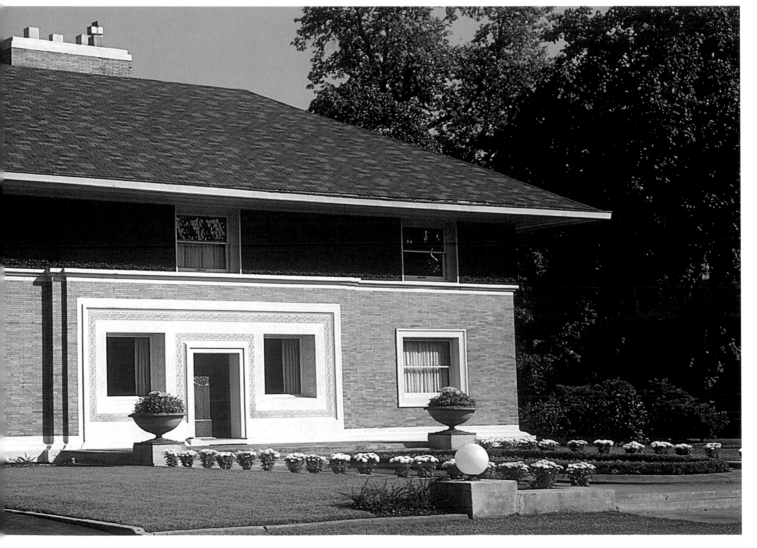

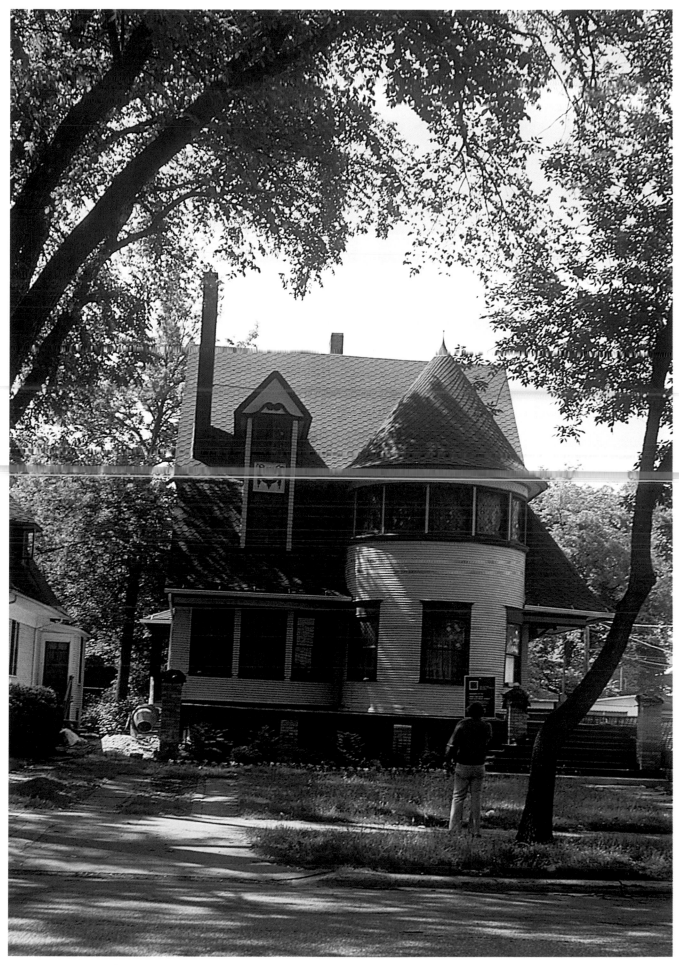

PLATE 8

Walter Gale House, 1031 Chicago Avenue, Oak Park, Chicago, Illinois 1893

Wright designed three houses on Chicago Avenue for Walter Gale, the one illustrated here for Gale himself, and the others as speculation housing. This was one of Wright's 'bootlegged' designs (page 31) and although it shows some originality, it is basically a *small residence without pretensions, as might be expected of a suburban house but which is not always the case. The one feature that suggests Wright's involvement is the strong overhang on the eaves and over the entrance porch. One of the other two Wright houses for Gale, 1027 Chicago Avenue (in spite of the numbering next door to Walter Gale's house) was bought by his brother, Thomas H. Gale, whose wife also commissioned Wright to build a house for her in Oak Park in 1909 (plate 12).*

The development of architecture in America, both North and South, reflects this influence as the Europeans established themselves in these areas, carrying their architectural heritage with them. It was on such a foundation that the first, essentially American, architectural styles emerged. The European influence was predominantly British and French, with some Spanish impact, especially in the South. One notable, predominantly British, contribution – known as the 'Battle of the Styles' – arose from a difference of opinion among professional architects which argued what the appropriate style for major architectural works should be – the Classical or the Medieval, both of which were visible in such buildings as the classically-inspired British Museum (founded 1753) and Barry and Pugin's Houses of Parliament (built 1840–60), which appeared in late medieval, Gothic revival form. This 'battle' soon filtered onto the American architectural scene and resulted, for example, in the head-to-head confrontation on Trinity Square, Boston, of the opposing merits of Richardson's Romanesque Trinity Church (1877) and the later classical, Italianate palazzo-style Public Library (1888) of McKim, Mead and White. It is important to recognize here that there was no search at this time for a new appropriate 'modern' style in Europe or America. Indeed, the idea of modernism was not expressed until the middle of the 19th century, and somewhat surprisingly by John Ruskin in his work *Modern Painters*, the first volume of which appeared in 1843. As we shall see,

Ruskin is not without significance in the development of Wright's own personal aesthetic.

This historicism was also largely true of domestic building although, with the increasing population and prosperity of the nation, larger and more imposing private houses were being built in either medieval or classical styles. Since both were in demand, most architects became accomplished through training in providing solutions in either style and Richard Morris Hunt, in the two examples finished in the same year (1895) and built for members of the Vanderbilt family, 'The Breakers' (Italian Renaissance Classical) and 'Biltmore' (French late Medieval and modelled on the château at Blois) provide the most impressive examples.

This concern, amounting almost to an obsession with personal private houses, has remained an American preoccupation since the middle of the 19th century and the history of the country's later architecture is as much the story of the development of the house form, suited to American perceptions, as it is to the physically much larger sphere of commercial and industrial buildings by which it is usually identified worldwide. It is a significant part of Wright's achievement that he provided inspiration and example for the essentially American expression of the domestic aspect of architectural form. However, before examining this, it is appropriate to make some further observations on the architecture of the period in order to

PLATE 9 right

R. P. Parker House 1019 Chicago Avenue, Oak Park, Chicago, Illinois 1892

PLATE 10 below

W. E. Martin House, 636 North East Avenue, Oak Park 1903

PLATE 11 opposite top

Frank Thomas House, 210 Forest Avenue, Oak Park 1901

PLATE 12 opposite below

Mrs Thomas Gale House, 6 Elizabeth Court, Oak Park 1909

It was during his period with Adler and Sullivan that Wright's career really began. During his time with the firm, and with Sullivan's financial help in allowing him an advance of salary, Wright married and bought a plot of land in a then rural outskirt of Chicago called Oak Park. Here, in 1889, he built a home for his wife, Catherine Tobin, which led to commissions for other domestic projects in the area. Demand was such that Wright had to work late at night in order to satisfy his many clients.

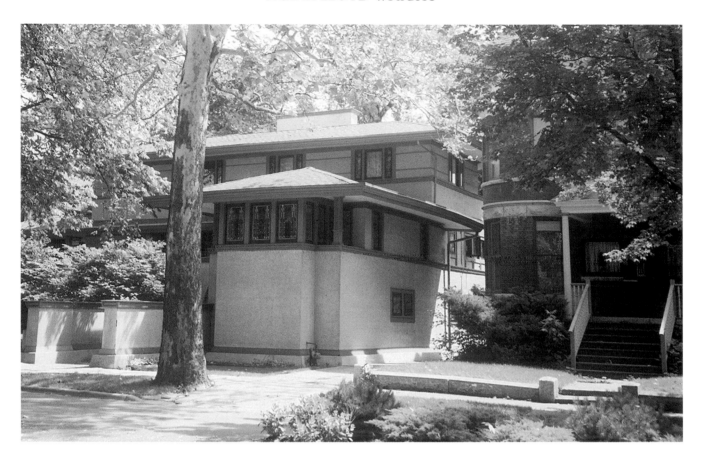

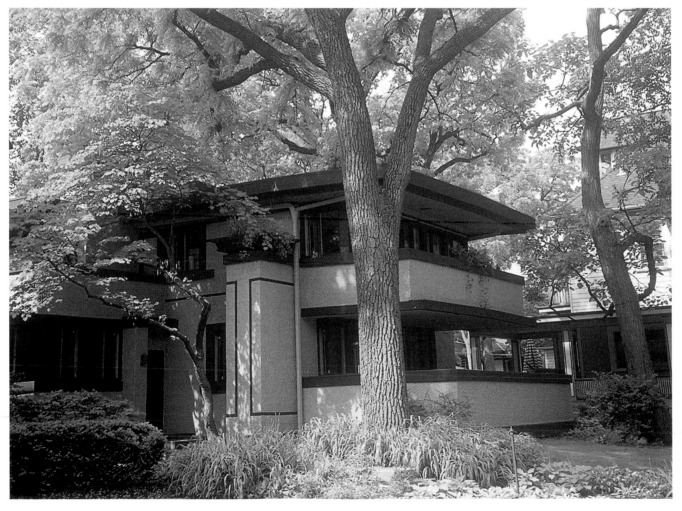

establish other and perhaps even more significant aspects of Wright's work.

Although the result was buildings which were much admired, and to which great intelligence and inventiveness were applied, it has come to be recognized that the aesthetic achievement was constrained by devotion to historical style. Towards the end of the century this limitation was acknowledged by some designers and architects who sought a more appropriate 'modern' style. Originally known as 'art nouveau' in France, but with many other names in other countries, a new style emerged which produced significant architecture during the last decades of the 19th century and the first years of the next. (It is interesting to note that it was called 'new art' rather than 'new architecture' and we still use the term art nouveau in architecture.) It was into the period of art nouveau ideas and practice that Wright's early first-hand experience of architecture is located and which had an important influence upon him.

Curiously, although there is no dispute regarding his birthday, 8 June, there exists some uncertainty in respect of the year of his birth. Early biographers give it as 1869, but it is now generally acknowledged to have been two years earlier. If one accepts this, then it was a very different world into which Wright was born only two years after the assassination of Abraham Lincoln. He was 36 before the

PLATES 12 and 11 above and opposite

Nathan G. Moore House, Oak Park, Chicago, Illinois 1895 and 1923

The two dates above indicate that the house was rebuilt after a fire in 1922 which nearly destroyed it. Wright redesigned the exterior to replace the original half-timber facing and almost completely reconstructed the first floor. The house, however, still retains much of its original character with steep pitched roofs and is on the same plan. The entrance porch has also been altered by the addition of elaborate carved decoration. Perhaps the most important feature reveals a Japanese influence, reflecting both the Japanese prints which Wright collected and the Imperial Hotel, Tokyo, just completed. The balustrade and flower urns are retained from the first house.

PLATE 15
Chauncey L. Williams House,
River Forest, Chicago, Illinois 1895

The World Columbia Exposition held in Chicago in 1893 included a great arch designed by Louis Sullivan, on which Wright is supposed to have collaborated. His interest in Japanese art was a result of the Exposition and this house is the first expression of a

nascent passion. Although the influence is not clearly expressed, the dormer windows do seem to recall a Samurai headdress, as does the unusually steep pitch of the roof. The already characteristic round-headed arch is apparent and sits somewhat incongruously in proportion to the eaves' overhang. The end view of the house with its tall chimney and windows joined with it, also calls Japanese dress to mind and the use of rough stones on the terrace fronting the main doorway seems to reflect an oriental influence.

Wright brothers made their first powered flight in 1903 and his architectural career was effectively launched, he was nine when two great, almost mythic figures of the so-called Wild West died in 1876; Wild Bill Hickok was murdered by Jack McCall and General Custer died at the famous battle of Little Bighorn. It was also in 1876 at the Centennial Exposition in Philadelphia, that Americans were first exposed to Japanese influences through the Japanese pavilion which was, as one observer put it, 'as nicely put together as a piece of cabinet work'. This initiated a craze for all things Japanese which prevailed as Wright was growing up and eventually resulted in Wright's long, low house designs. He was 13 when the Eiffel Tower revealed steel as a possible building material, a time when the rail systems were still new (a rail link across the States had not been completed by the time he was born), the automobile still remained an impracticable and illegal possibility, and in the expanding city complexes there existed no skyscrapers. Wright's early life was therefore saturated with the pioneering spirit of the great new nation.

His father and mother, William Cary Wright and Anna Lloyd Jones, were living in Richland Center, Wisconsin, and Frank Lloyd was their eldest child. His mother, a dedicated teacher, had great ambitions for him and had decided from the time he was born that he should become a great architect. To this end, she introduced him early to the writings of John Ruskin (1819–1900) who had by the 1840s,

while still a young man, begun to exert an almost mesmeric influence over Victorian aesthetic values so that, by the 1870s, when Wright came to know of him, he was already the doyen of Victorian art and society. This, incidentally, gave his later writings on sociological matters an authority in the developing socialist movement and had its effect on William Morris, the Workers' Educational Association and the Working Men's College, in London, where Ruskin himself was a teacher. Ruskin continued to be a strong influence on him throughout Wright's life.

Another early influence came directly from Wright's mother when she introduced her son to Froebel, the German educationist's system of children's games, which consisted of different ways of arranging blocks and coloured shapes. This perception of volumes, voids, planes and colours increased Wright's appreciation of shapes and masses, enabling him to understand their relation to design. From his father, an itinerant preacher with a deep passion for music, he acquired a passion for Bach and Beethoven and thereby gained an important understanding of structural form and, perhaps more importantly, a perception of the abstract qualities inherent in the arts: Shakespeare's 'concord of sweet sounds'. It is in this perception of the potency of abstract forms for the artist/architect that Wright's development was focused and which gives his architecture its individual resonance that is easily recognizable if not always understood.

PLATE 16
Arthur Heurtley House,
318 Forest Avenue, Oak Park, Chicago,
Illinois 1902

This house is one of the finest examples of Wright's early Prairie Style and its long, low horizontal aspect and the dark Roman brick colour recall the character of the single-storey log cabin. The horizontal is emphasized by the addition of protruding brick courses and the continuous frieze of casement windows which Wright called a 'light screen'. The house is square in plan and fronts the street while retaining a sense of privacy, only partially contradicted by the round-headed entrance, and stands on the usual platform base. The Japanese influence is evident less in the details than in the air of distinction achieved by the use of fine materials. The main living area is on the first floor while a large children's playroom is located on the ground floor.

Wright's life was not a clear passage through untroubled waters to a promised land. It was beset with a number of distressing and disruptive events, the first of which occurred when he was 18. His father, an unstable and volatile character, divorced Wright's mother and departed never to return. The influence of this turn of events on Wright was twofold; first, it drew him ever closer to his mother and her family when, after a period in Massachusetts, the Wright family moved back to Madison, the capital of Wisconsin, to be near his mother's family, the Lloyd Joneses. It was at this time that he witnessed architectural design in action when his uncle commissioned an architect, J. Lyman Silsbee, to build a new chapel for their farming community in the Spring Green valley. Secondly, it left him with a continuing distrust of the widely and deeply-held Christian belief in the permanence of marriage.

His mother, though deeply saddened at his departure, accepted her son's decision to go to Chicago to study architecture and he entered Silsbee's Chicago practice. In 1871, Chicago had been devastated by a great fire which had produced a greater workload for architects in the succeeding decade and there were still opportunities in 1887 when, at the age of 20, Wright joined Silsbee. A successful but not greatly original architect, Silsbee was a practitioner of what is known as the Shingle Style, which, in the light of his later domestic work was to become a significant influence. Wright, perhaps not surprisingly, found Silsbee uninspiring

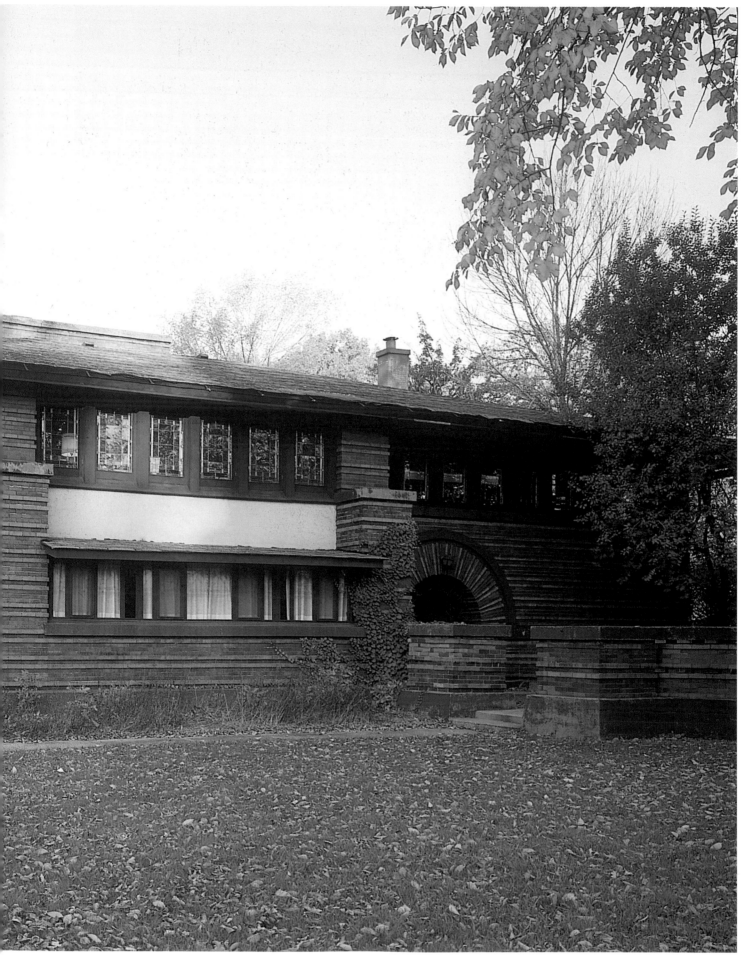

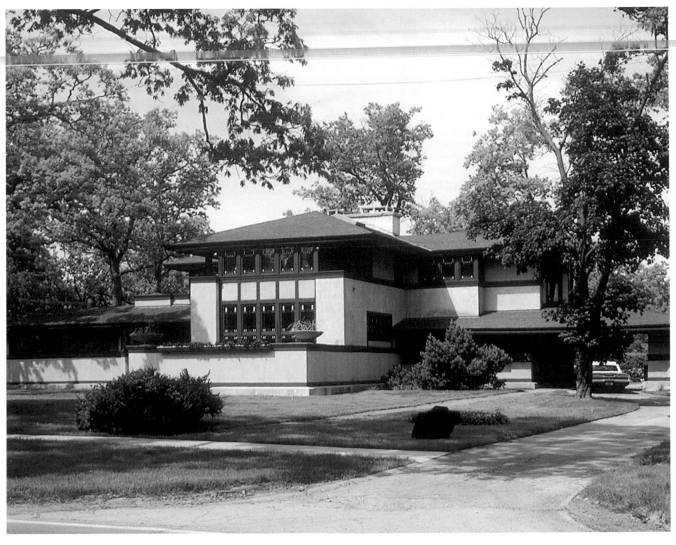

PLATES 17 and 18 opposite
Ward W. Willitts House, 715 South Sheridan Road, Highland Park, Chicago, Illinois 1902

The expansive but controlled design of this Prairie house makes it one of the finest of the genre, described by Henry-Russell Hitchcock as 'the first masterpiece among the Prairie houses'. On a cruciform plan, this large house contains the servants' quarters with a butler's pantry on the ground floor as well as the usual living room, dining room and kitchen. The upper floor includes three bedrooms, a library and nursery, and utilizes the Greek Cross form which, on the ground floor, is extended left and right to form a strongly directional character with porch and porte cochère. *The structure is of steel, wood and plaster with exterior wood trim. The dark linear and light colour shapes are finely balanced.*

PLATE 19 below
William G. Fricke House, 540 Fair Oaks Avenue, Oak Park, Chicago, Illinois 1902

This is one of the tallest of the Oak Park houses, constructed on three floors and giving a feeling more of an aggregate of parts than of a unified wholeness found in, for instance, the Ward Willitts House (opposite). There is none of the control of the horizontals and verticals that is usual with Wright and, curiously, the effect is enhanced by the dark linear outline of the horizontals. It could be argued that the Froebel influence of Wright's youth is evident here in unresolved form. Two of the tall windows run up through a stairwell while the third, surprisingly, extends through from one floor to another. This emphasis on the vertical in a Prairie Style house indicates Wright's continued creative exploration with an established, essentially horizontal style.

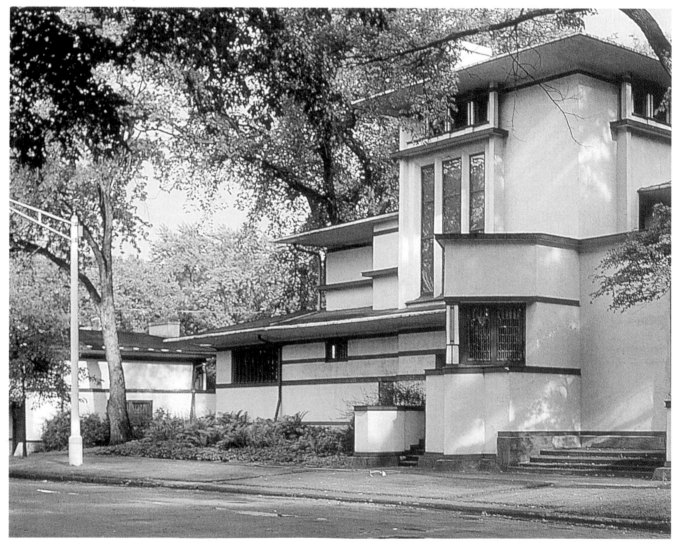

PLATE 20

Larkin Company Administration Building, 680 Seneca Street, Buffalo, New York
1904. Demolished 1949–54

The earlier of the two great non-domestic commissions that Wright received in the first decade of his practice, the Larkin Building, built for Darwin D. Martin, the owner of the Larkin Mail Order Company, is recognized as a masterpiece of industrial design, reflecting in its solid form the importance of business, the enduring nature of commerce and the power of industry. Unusually fenestrated and with massive brick fronting piers reminiscent of great Egyptian temples which have lasted thousands of years, it sits seemingly permanent and indestructible. Sadly, and an architectural tragedy, it was neither, and was demolished by developers in the

early 1950s. That it cannot be illustrated in colour is regrettable, but it does not diminish the importance of the building's innovative design.

Despite its markedly industrial aspect, it is essentially an administrative centre for a mail order firm, requiring a large secretarial contingent with administrative staff in close proximity. The result was the whole central core being conceived as an open space, lit from above for the secretarial staff with the administrators lodged in surrounding tiered alcoves lit by side windows. The clear, uncluttered, open central area was achieved by locating storage and filing cabinets in the spaces between the main supporting piers. An important innovation was that air conditioning was used for the first time. Wright's involvement with the project arose through his contact with Darwin and William Martin, for whom he had already built houses.

and departed the next year to join one of the most successful practices in Chicago, that of Adler and Sullivan, on a five-year draughtsman's contract. This put Wright in direct contact with the 'modern' style of art nouveau since Sullivan was one of its most famous exponents in America. To this, he applied Ruskin's theory of an architecture of encrustation – an added if indirect example of Ruskin's influence on Wright.

It was a propitious moment for change, the firm being in the mainstream of architectural thinking at the time. As indicated earlier, the architectural philosophy was changing towards the end of the century. On the one hand, there was the impetus of new building required by industry and a rapidly growing population and, on the other, the development of the recent practical technology made possible by new materials – steel, for instance, replacing iron. The two centres of greatest change were New York and Chicago; consequently Wright was at the hub of this great architectural programme in that he was already working for Adler and Sullivan. It was the beginning of the great age of skyscrapers, made possible by the use of the Bessemer steel process in providing a sturdy framework and, not less decisively, by the invention of the elevator by Otis, in the absence of which skyscrapers would have been totally impracticable. Another important development was the availability of cheap steel as a result of the commercial enterprise of Andrew Carnegie in bringing down the price.

Art nouveau and the Tiffany style were then at their most popular and Louis Sullivan was its architectural genius. To Wright, he was the *lieber Meister* (beloved Master) and Sullivan's decorative detailing, while he did not imitate it, greatly influenced Wright. They were both convinced that a new character was needed for the growing egalitarian nation, believing that the historicist styles reflecting a long-gone society in a different continent were now inappropriate. By this time, Wright had achieved a close working association with Sullivan and was in charge of the the firm's domestic programme. They found in the widely admired *Grammar of Ornament* (1856), by Owen Jones, a sourcebook of exotic Eastern and Middle-Eastern design, totally unconnected with Europe.

Accompanying this stylistic development away from both classicism and medievalism, the most important change was being inspired by engineering imperatives. Steel provided the framework for large structures, just as centuries earlier wooden beams had been used to support Tudor half-timbered houses, but on a vastly greater scale. Before the end of the 19th century, cast and reinforced concrete was being developed to provide a more appropriate cladding for the large steel frames and to take the place that either brick or stone had occupied in earlier, more modest constructions. Concrete is a substance which has no tangible form of its own, unlike stone and wood, but which can be cast to assume the form into which it is poured and which then sets

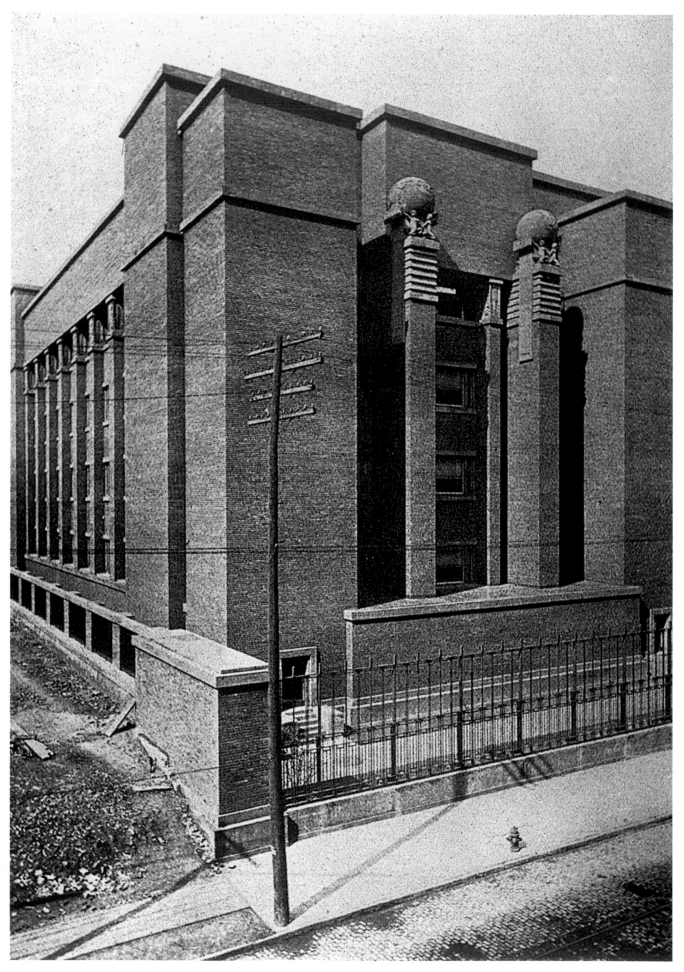

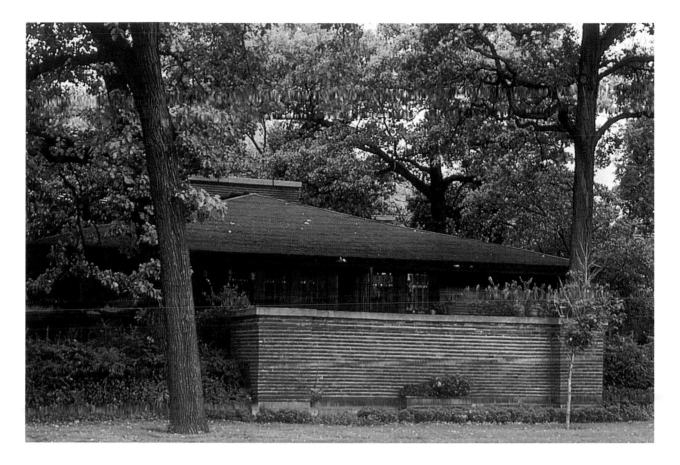

permanently into that shape. The growing possibilities of its
use were explored in the early years of the century, when
steel replaced cast or wrought iron as a structural support.

It was during his period with Adler and Sullivan (Adler
left the partnership in 1895) that Wright's career really
began. Although (though hardly acknowledged by him)
Wright had early gained considerable technical knowledge
from Adler's engineering expertise, it was for Sullivan that
Wright had the greater reverence. During his time with the
firm, and with Sullivan's financial help in allowing him an
advance of salary, Wright married and bought a plot of land
in a then rural outskirt of Chicago called Oak Park. Here, in
1889, he built a home for Catherine Tobin, his wife
(plates 2–4). By this time, Wright had become the practice's
chief assistant and in 1890 was given responsibility for all the
firm's domestic commissions. This focused his attention on
what was to become the most important and creative area of
his architectural *oeuvre*, although he is perhaps publicly best
known through his larger commissions, such as the
Guggenheim Museum, New York, completed after his death
in 1959 (plates 64 and 65).

In the neighbourhood, domestic projects increased
considerably and Wright had to work late at night to keep
up with demand. As his reputation increased, he began to
undertake private work outside office hours which, although

PLATES 21 and 22 above and opposite

Edwin H. Cheney House, 520 North East Avenue, Oak Park, Chicago, Illinois 1904

*This small and compact single-storey house is designed on an
unusual open plan, with the main room forming a continuous
flowing space consisting of dining, living and library areas, and with
a large fireplace alcove as a focal point in the centre back of the
living area – an example of the hearth as centre of the home, as
noted earlier. The four bedrooms are ranged along the rear of the
house. It was in the course of the construction of this house that, as
recounted on page 37 et seq., Wright's ultimately tragic association
with Cheney's wife began.*

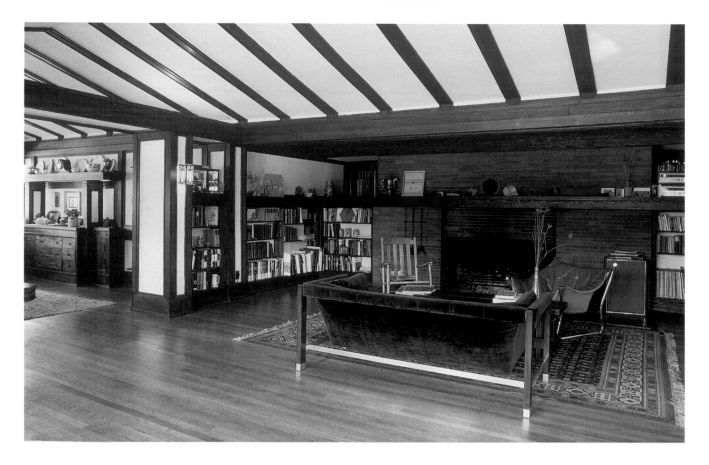

not expressly forbidden in his contract, he himself described as 'bootlegging'. This caused a breach between Sullivan and himself (which lasted 20 years) and led him, in 1893, to open his own practice in Oak Park. He built a studio extension to his house and began his extraordinary progress towards a worldwide reputation. His personal creativity was not confined to architecture: part of the necessity for the bootlegging was an increasing need to provide for his family as it grew – five children in the first nine years of married life.

From the turn of the last and towards the end of the first decade of the present century, the first stage of Wright's career is identified with the development of what has come to be known as the Prairie Style, a first-generation descendant of the Shingle Style of Henry Hobson Richardson, and adopted by Silsbee. Although his is the name associated with the Prairie Style in popular understanding, there were a number of architects in Chicago, and subsequently elsewhere, who participated in its development. Its name suggests the then-growing myth of the wide open spaces of the West, of log cabins and reckless, ruthless cowboys, of overhanging eaves and low-pitched roofs, of simple interiors and single storeys, and to this extent it does convey something of the intended character of the style. It is, however, more sophisticated than its name

suggests. It was created to supply a more homogeneous creation of useful space and simple construction than had become common in domestic architecture of the period. For the Prairie houses, Wright himself identified nine principles on which a unified structure should be achieved.

1. Number of parts to be minimized to produce a unity.

2. House to be integrated with the site by emphatic horizontal planes. (Wright is here echoing one of the principles of classical architecture.)

3. Rooms as boxes to be replaced by spaces created through the use of screens and panels.

4. House to be raised on a platform above ground level with main living on upper floor to provide better all-round views.

5. Light screen windows to replace rectangular window holes in walls.

6. Materials minimized in number and with ornamentation expressive of each material and all designed for industrial production.

7. All services (plumbing, heating, lighting etc.) to be incorporated as architectural features into the building fabric.

8. Furnishing in keeping with building.

9. No 'fashionable decorators' to be employed.

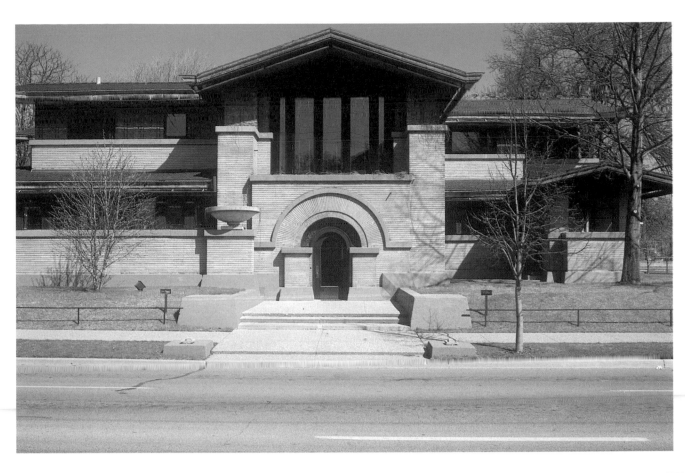

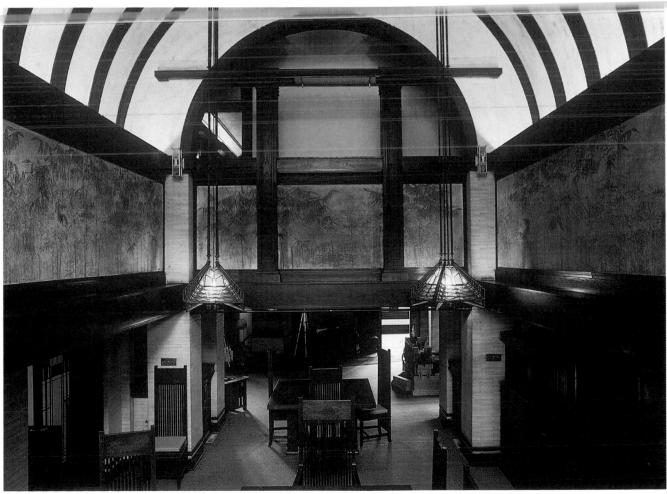

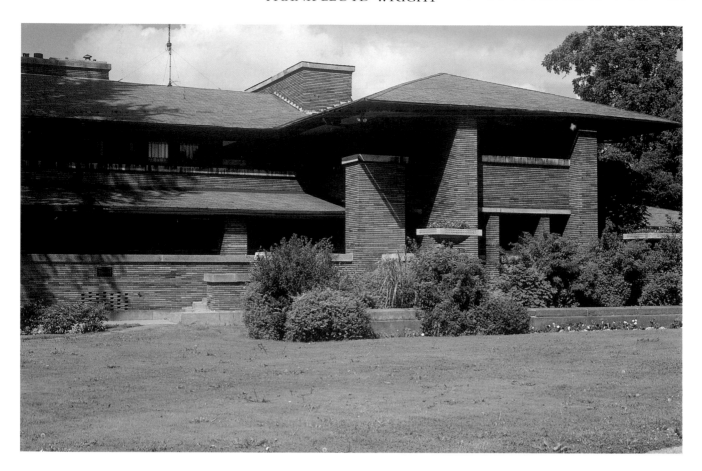

PLATES 23 and 24 opposite above and below
Susan Lawrence Dana House,
East Laurence Avenue, Springfield, Illinois
1903

PLATE 25
Darwin D. Martin House, 125 Jewett
Parkway, Buffalo, New York 1904

As a result of an unlimited budget provided by his client, Susan Dana, a member of the local élite, this is one of the most lavish of Wright's early houses. Even the liberal original design was later enlarged (1905) by the addition of a library on the left side of the house and accessible through a covered walkway. The house is so large that in scale it suggests a public library or conference centre rather than a private residence. With the opportunities provided by virtual financial freedom, Wright experimented for the first time with two-storey rooms and employed his favourite designers and artists, including George Niedecken and Richard Bock, to provide murals and sculptures, while he himself designed the decorative glass panels and the furniture and fittings. It is a summation of his ideas applied to domestic design at this early stage of his maturity, only rivalled 20 years later by the luxurious Aline Barnsdall House (known as the Hollyhock House, see plates 38 and 39).

In 1901, Wright published designs for a Prairie Style house in the Ladies' Home Journal which through its wide circulation brought him even more fame than his actual architecture which, of course, was essentially localized. Popularity was enhanced by the fact that the designs, in the form of working drawings, were supplied for $5. They were intended as low-cost houses but an expansive and expensive version of these original designs formed the basis of a house for Wright's close friend and supporter, Darwin Martin, which eventually cost over $100,000 – an extraordinary sum for those days. The result, although grand, is not entirely satisfactory since the intrinsic nature of Prairie houses lies in their unified simplicity which is at variance with the scale of this complicated house on a large site. It is, in fact, two houses – a main house and a smaller one for Martin's daughter, linked by a long, pergola-covered walk. The usual Wrightian features – overhanging eaves, low podium, urns and other decorative elements, make it clearly his: but it is somewhat out of sympathy with his essential philosophy. It is interesting to note that Wright also designed the furniture which is as uncomfortable as it looks. As he himself admitted in his autobiography: 'I have been black and blue in some spot somewhere all my life from too intimate a contact with my own furniture.'

PLATES 26, 27, 28 and 29 opposite and below

Unity (Universalist) Church and Parish House, familiarly known as Unity Temple, Oak Park, Chicago, Illinois 1906

The Wrights were Unitarians and when their local church was burnt down in 1904 it was natural that Wright should seek the commission to build its replacement, especially as he had already achieved a good reputon as an architect in Oak Park. There was some reservation among the congregation since he was seen as a 'modern' architect and the church they had lost was medievalist with all the associations of traditional church building. They were certainly shocked at the result which Wright himself described as a 'concrete monolith'. It was like no church they had ever seen or, indeed, anyone had seen at that time. It was closer to the great Larkin Building in its monumental solidity than to the layman's concept of a church, with its large windows and intricate external and internal decoration. The main source of illumination for the new temple came from large square decorated glass panels over the whole central core, which gave a deep sense of quiet peace and a reverential and spiritual atmosphere to which the congregation soon responded, reflecting Wright's universalist views of the sacred nature of all activity to be expressed in architectural form. There is a certain poignancy in recalling the affront with which Wright, at that time, in his association with Mamah Cheney, was preparing to assail public sensibilities.

The poured concrete method for the structure was not the first time it was used by Wright. It is used in some of his early domestic buildings in small quantities but he had some difficulty in convincing the building committee and suggested that the fine pebble aggregate finish would in time come to resemble a granite surface. Over the years, however, the surface has posed some problems but the 'monolith', with piers at the corners echoing the Egyptian character of the Larkin Building (plate 20), has acquired a character which makes the name Unity Temple highly appropriate. The complex, as its full identification indicates, consists not only of the square planned church hall but also of a rectangular social hall which includes provision for a Sunday School class. This area is also lit by decorated glass ceiling panels. The church and social hall are linked but separated by a raised terrace which provides access to both.

This last and typical outburst is an indication of Wright's philosophy, and indeed his intention. It is to create a unified work of art; an inside/outside sculpture with an added spice – it should also be useful. But not, of course, altered. This identifies him early in his career as artist/architect – a role he consciously exploited in his later work. These houses have common characteristics: a central service core, structural screens guiding internal flow without disturbing a perception of unity, and a flat platform base defining the land/house relationship.

During the first decade of this century and as well as the Prairie and other houses, Wright completed two early public buildings of great significance, the Larkin Building in Buffalo, and the familiarly named Unity Temple in Oak Park: both these buildings extended Wright's range of work. The Larkin Building is an expression of an industrial aesthetic in a commanding form and will be discussed later, as will the Unity Temple which is the first of a number of churches for different religious denominations that he designed later. Religion and faith had been an important factor in Wright's development and he believed that, apart from practical uses where different rituals demanded a different design, each place of worship should reflect the spirit of that faith – which he modestly asserted he would be able to identify and supply. It is interesting to examine his solutions which are undoubtedly varied; but it has to be observed that the possibility of designing for a faith to which

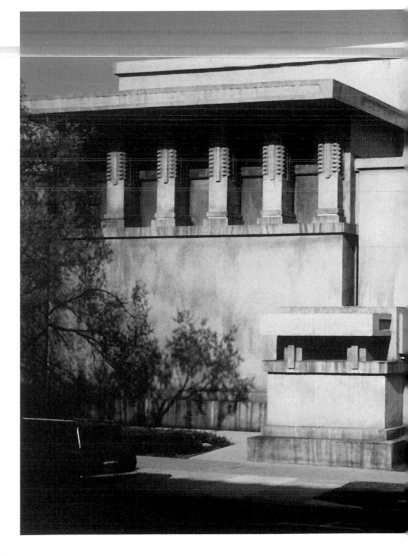

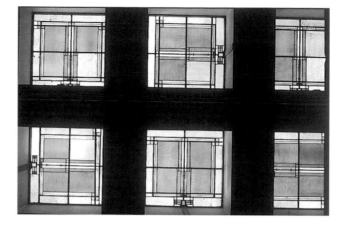

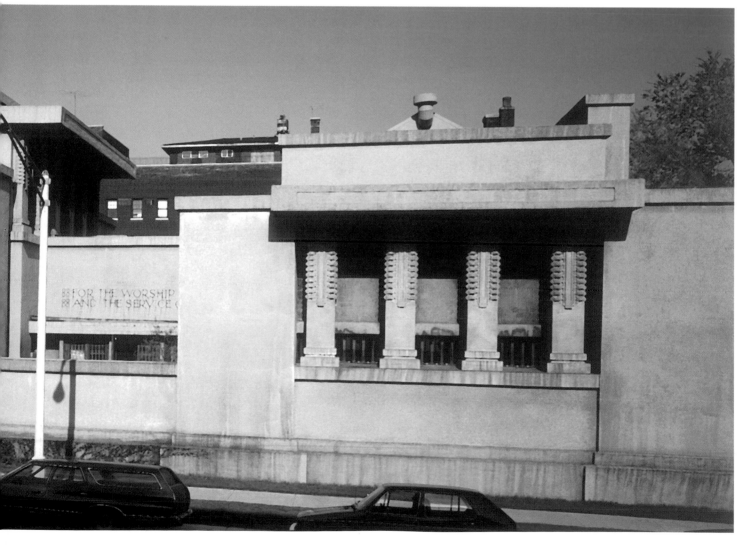

PLATES 30 and 31 opposite and below
Frederick C. Robie House, Chicago, Illinois 1909

Generally regarded as one of the most successful and innovative of Wright's early houses but retaining Prairie Style characteristics, the Robie House is more of a joint venture between client and architect than is usual in Wright's normal modus operandi. As has been mentioned several times, Wright liked things done precisely and exclusively as he wanted them. This client, Frederick Robie, was however an unusual man himself, a manufacturer of automobile supplies and, perhaps more significantly, a successful inventor who had asked Wright to design for him a modern house with as much technological innovation as seemed to him appropriate. Robie made a number of suggestions himself, including an adaptation of an industrial integrated vacuum-cleaning system. The result was a highly unusual house on a restricted urban site. Although, with a

cruciform core, the effect of the design is one of extreme length along the street-front, emphasized by the long overhanging roof composed of steel girders which stretched more than 20ft (6m) beyond the wall supports. The effect of delicate lightness combined with sturdy construction is unique in Wright's Prairie houses.

Internally, the design is even more innovative. The lower ground floor is externally partially concealed by the heavy brick walling with concrete top course, emphasizing the horizontal throughout, and includes a concealed entrance hall, a billiard room, a children's playroom, laundry and boiler room together with integral garages with special doors invented by Robie. The living room, dining room, guest-room kitchen and servants' quarters are on the first floor while the part second floor contains the master suite. The ground and first floors are unwalled, offering a continuous spatial flow only interrupted by the large central chimney stack. The fixtures and fittings were designed by Wright and include the large flattish flower urns which had become a visual signature theme.

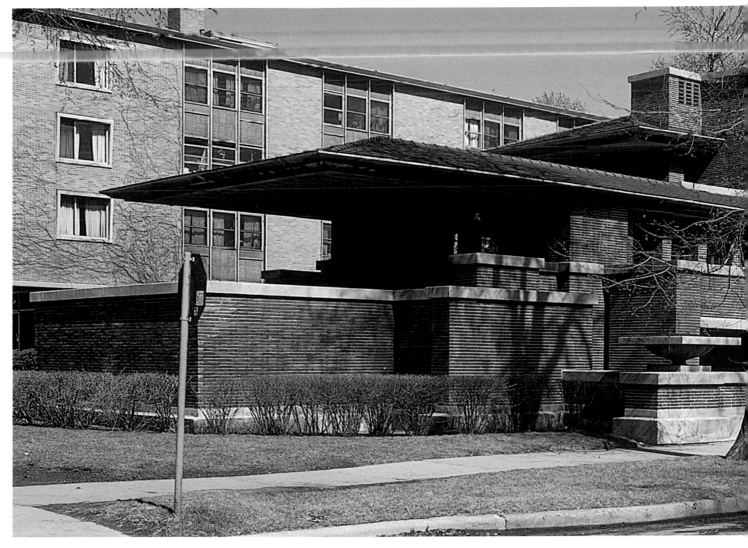

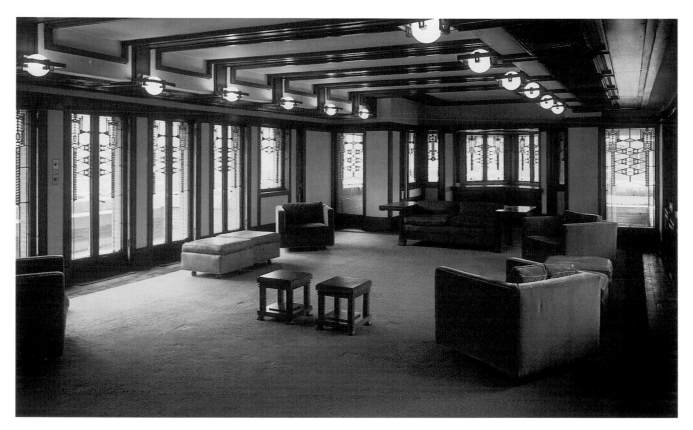

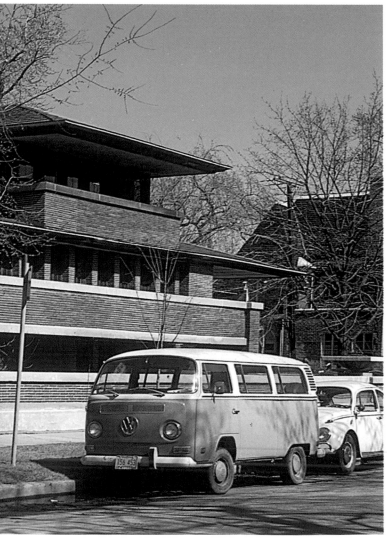

one does not oneself subscribe is still much disputed. It was during these years that Wright formed an atelier of craftsmen and technicians to realize his vision and his search for a total work of art. (One is tempted to link this programme with the later philosophy of the Bauhaus in Weimar and Dessau, where, in Gropius' new building, architecture became the physical link between the art/craft and the technical/ workshop.)

In 1904, Wright designed a house in Oak Park for Edwin H. Cheney (plates 21 and 22), thus initiating a sequence of events which was to cause great upheavals. Wright, at their first meeting, found himself inextricably drawn to Cheney's wife, Mamah. She was a trained librarian and an interesting, liberally-minded, intelligent and lively woman. Although married, and with a large and growing family, Wright became so infatuated with her that his friends, recognizing the potentially disastrous effect on his family and career, attempted to dissuade him from continuing with the affair. When this failed, they devised a plot through other clients, Mr and Mrs Ward Willetts, whereby they sought to persuade him to visit Tokyo with them when hopefully he would swiftly come to his senses.

Wright had long been interested in Japanese culture and artefacts through the great Chicago World Columbian Exposition of 1893, on which he had worked while still with Sullivan, and in which he had seen the Japanese Government's reconstruction of the Ho-o-den Temple. He

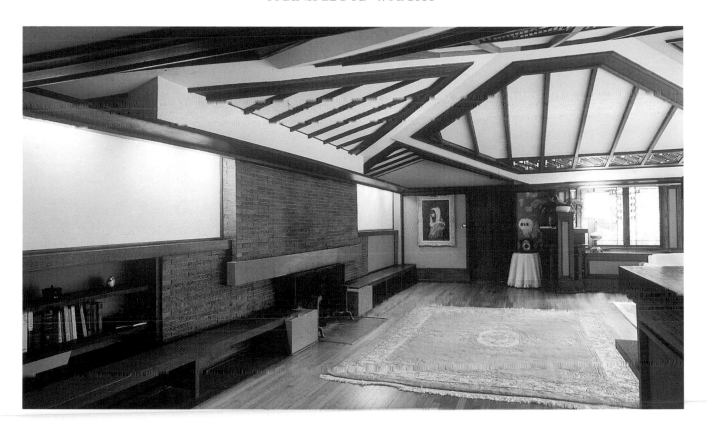

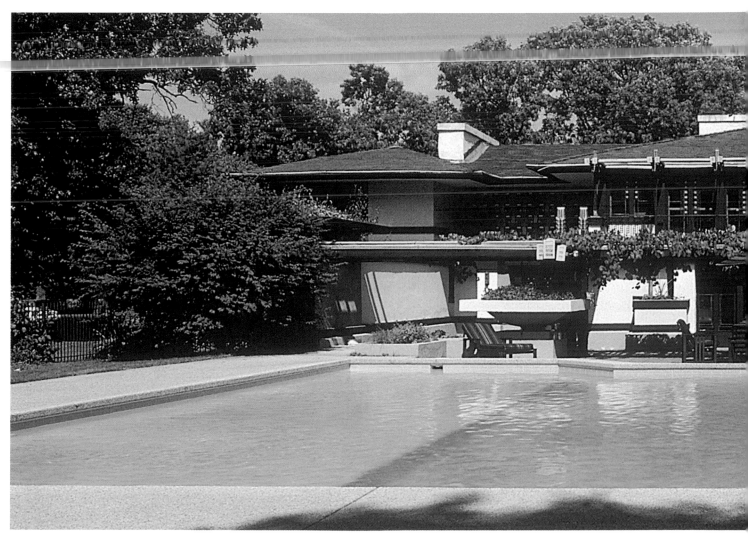

PLATES 32 and 33 opposite and below
Avery Coonley House, Riverside, Illinois
1908

Many of Wright's clients were also close friends who accepted his authority where matters of design were concerned, enabling him to carry out his intentions without conflict. Of course, this freedom offers the architect the opportunity to establish his originality with clarity and without compromise. Wright always took full advantage and in such projects as the Coonley house his individual genius is fully evident. Coonley had acquired a large site in a fully laid-out community designed by Frederick Law Olmsted and Calvert Vaux, at that time the most successful landscapist/architect partnership.

The level ground which the house overlooked resulted, as in the Robie house (plates 30 and 31), in the main living areas being on the first floor. With the extensive site, Wright was able, in addition to the large house, to provide an outside pool, a sunken garden, stables and garage block, a gardener's cottage and a chicken house.

A playhouse was added to the main house in 1912, based on a Greek cross plan, and which Wright himself believed to be one of his finest creations. It is a simple undecorated structure housing a workshop and kitchen, the main feature being a stage and dressing rooms which occupy the whole of one leg of the cross. Externally, the opposition of planes and masses, horizontals and verticals, provides a satisfying whole.

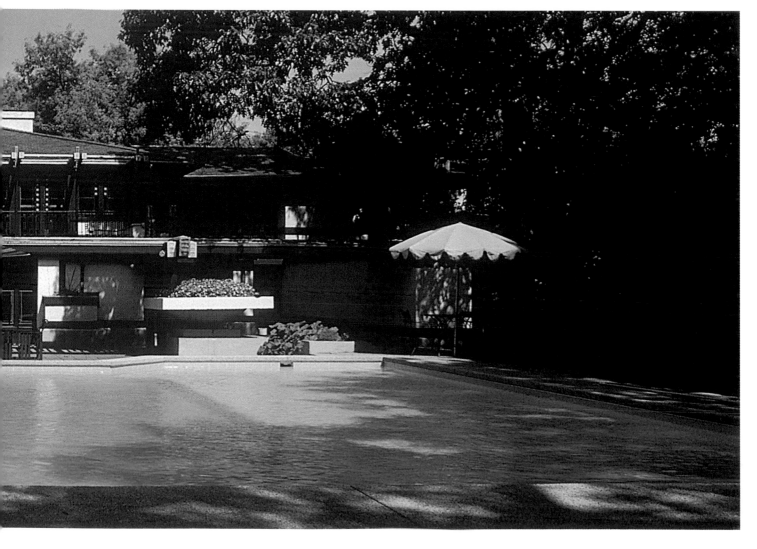

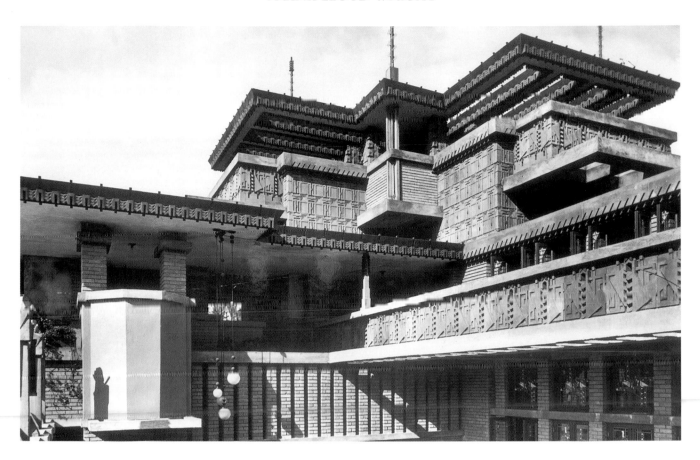

PLATES 34 and 35 above and opposite
Midway Gardens, Chicago, Illinois 1914

*Although Wright is recognized as a predominantly domestic architect
and it is true that most of his famous buildings fall into that category,
when he is asked to address a larger-scale structure and one destined
for a different purpose, as for example, Midway Gardens, his
solution is always original and impressive. In some unrealized
designs such as his Lexington Terrace, Chicago (1909) or the
Doheny Ranch Development near Los Angeles (1921), his
approach is almost visionary, and it is more than likely that, had it
survived, the demolished Midway complex would have proved
immensely influential. Much of the credit must be given to Paul
Mueller, an engineer member of Wright's atelier and the other
sculptors and designers who provided the decorative elements of the
swiftly built large complex of entertainment, what Wright described
as 'a social response to the dance craze'.*

*Midway Gardens, as its date suggests, was created at the wrong
time and was demolished in the 1920s; but as a solution to an
interesting commission it should have been an inspiration to later
architects. Commissioned by the son of one of Wright's friends and
clients, Edward C. Waller, it was intended to provide a splendid
and spacious pleasure and cultural centre in the heart of Chicago,
reminiscent of London's old Vauxhall Gardens. Partly, perhaps,
because the Chicagoans were not ready for such a concept, but more
because it was begun just before the First World War and opened*

*after it had started, when the national mood was not exactly festive,
it was something of a failure. The final nail in its coffin was
delivered by Prohibition in 1919, by which time it had been turned
exclusively into a beer garden. The scheme was ambitious: it
consisted of a large restaurant which faced outward onto the street
with a great open court with bandstands and stages to the rear.*

*Although Wright had completed the design at great speed and
work began quickly before being fully financed by the budgeted
$350,000, cash continued to be in short supply. This unhealthy
situation was accompanied by a general dissent among the number of
artists Wright employed, one at least failing to meet Wright's
aesthetic standards. Hitchcock claimed, in his* In the Nature of
Materials, *which examined Wright's work up to 1941, that Wright
was independently involved with the developments in European art
in the first decade of the century while American art was, until 1914
and the Armory Show, still aesthetically stranded in the 19th
century. After two years, during which time the Gardens made a
substantial loss, they were sold to a brewer who converted them into
an unashamedly German-type beer garden, just in time for
Prohibition to wreck the whole venture and to precipitate the
demolition of the whole complex for conversion into housing. The
photographs that remain reveal the Gardens to have been a visionary
design showing great decorative invention, including the design of cast
concrete blocks which anticipate Wright's 'textile block' method of
the 1920s.*

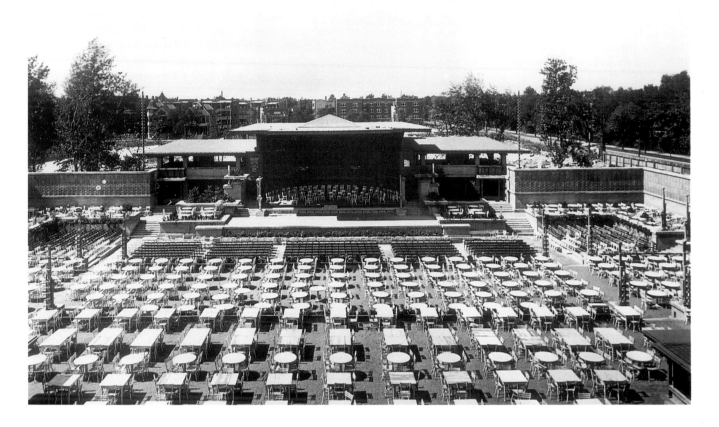

enthusiastically accepted the offer. The result was a lifelong interest in Japanese prints, which to some degree influenced the design of subsequent Prairie houses and much of his later architecture. The visit to Tokyo did not, however, succeed in its objective of deflecting his interest away from Mrs Cheney and in 1908 Wright asked Catherine for a divorce. Because of her large family, this was indeed devastating news to which she found herself unable to immediately respond: at the time of Wright's visit to Berlin in the following year, the matter had yet to be resolved.

The visit to Berlin was to oversee the publication of a prestigious portfolio of Wright's work by an important German publisher, Ernst Wasmuth. The portfolios of drawings and designs, known as the Wasmuth portfolios (issued in two parts), were to become architectural publications of extraordinary influence and firmly established Wright's reputation in Europe. Mies van der Rohe later acknowledged that he had been inspired by the 'clarity of language and disconcerting richness of form' in the portfolios and that he had followed 'the developments of this rare man'. It has been suggested that later, after the rise of Hitler, they influenced a number of German architects in their choice of America rather than elsewhere as a place of refuge from Nazism.

Wright's life changed irrevocably when it was discovered that Mamah had joined him en route and that they had lived in their hotel as man and wife. Oak Park's local community was scandalized and when he returned with Mamah in 1911 his position grew increasingly difficult. His practice declined, Catherine continued to refuse him a divorce, and friends and clients continued to admire but began to waver in their allegiance. It was largely the support of Wright's mother that helped him through this difficult period. She gave him land that she owned at Spring Green on which he decided to build a spacious home and studio, with a farm surrounding it.

The story at this point becomes both bizarre and tragic. Wright, still married to Catherine, set up home with Mamah, by this time divorced, together with his mother. The Lloyd Joneses were dismayed and the locals, mostly devout Protestants, regarded the arrangement as iniquitous. Wright called the house 'Taliesin', a name that has become famous in America. It derives from the Welsh and means 'shining brow', in recognition of Wright's Welsh origins and is an indication of a mystical and romantic side to his nature.

In 1914, however, when he was beginning to put his career together again, tragedy struck with devastating effect. Wright, summoned to Taliesin by a report of a serious fire, met his long-suffering client and friend, Edwin Cheney, who was coming to see his children, at that time living at Taliesin. They arrived there together to be confronted, not only with the effects of an all-consuming fire, but with the

PLATES 36 and 37 below and opposite
Imperial Hotel, Tokyo, Japan 1914–22

Wright was awarded one of his most important commissions while he was working on the Midway Gardens project. He was invited to Tokyo to bid for a hotel to house the Emperor's guests and other visiting dignatories. It is another sadness of architectural history that this building was demolished as late as 1968, although it was recognized as one of the great buildings of the 20th century. Commercial cupidity was the cause and the extraordinary structure was replaced with another, undistinguished, hotel. It is particularly poignant since, soon after it had been completed, it had survived the most violent earthquake in Tokyo's history. It was in fact the engineering genius of his colleague, Paul Mueller, of the great H-plan structure as well as Wright's forethought that had been most admired. Since it was part of the contract that the possibility of earthquakes should be considered and the Japanese variety generally wrought terrible damage and loss of life through the fires that invariably accompanied them, Wright was obliged to make very special provisions for the hotel. Indeed, in the event, most of Tokyo was destroyed while the hotel stood, a proud haven to which many people rushed for shelter. One interesting element of the design was Wright's inclusion of a number of pools within the hotel court, decoratively treated but intended by him to staunch the fires which he knew would be bound to occur. Wright's structural solution, masterminded by Mueller, was ingenious and again effective. One problem was the 50ft (15m) of mud subsoil which he overcame with the introduction of grouped tapering concrete columns linked to continued reinforced concrete floors above, floated on a varying-height base. Wright visualized it as something like a waiter carrying a tray balanced on his upturned fingers. Another effective element was that the walls, made of brick and concrete, were tapered upwards to reduce weight without losing the strength needed on each level. The exterior was richly decorated with proto-Japanese and pre-Columbian features, while a rough-surfaced lava stone was used, carved into abstract decorative forms as a foil to the delicate brickwork. Sullivan, just before his death in 1924, added an appropriate postscript when he wrote: '...it stands today, uninjured, because it was thought-built so to stand.'

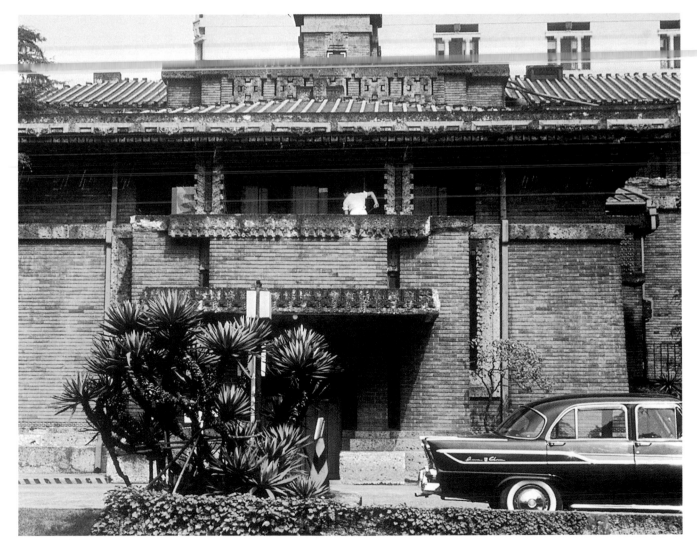

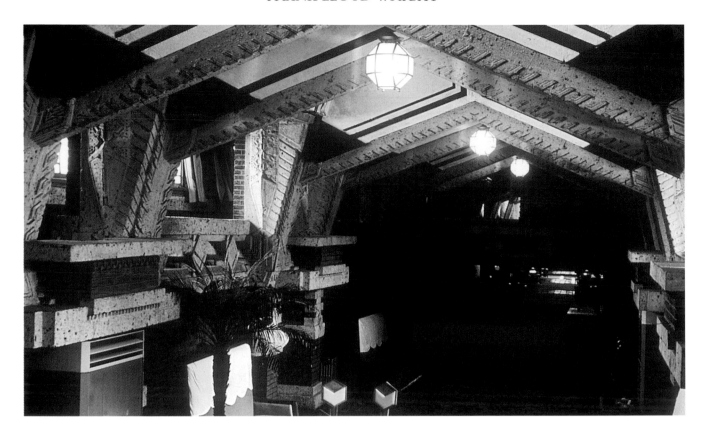

tragic news of a horrifying murder. Mamah, the two children (a boy and a girl) and four of Wright's employees had been hacked to death by a deranged household servant who had previously set the fire which had already destroyed two-thirds of the house.

Devastated by the tragedy, Wright's travails were only just beginning. At this dark period in his life, one of the many that came to console him was a woman named Miriam Noel who was to cause more aggravation and long-term difficulties than Wright could possibly have anticipated or certainly deserved.

Although one would have thought that the unconventional domestic arrangements at Taliesin would have led him to adopt a low profile for a period, it is characteristic of Wright that at this very time he contrived to improve his public image by designing his first skyscraper, the San Francisco Press Building, in 1912. The design, half as tall again as anything already in existence, was in a thin slab form with an overhanging upper level and devoid of the usual added historicist decoration. The emphasis is on simple vertical piers, punctuated with horizontal exaggerated window sills. In time, it predated the abstract designs through which the modern skyscraper has been commonly recognized since the 1930s.

In 1913, when Wright's passion for Japanese prints was fuelling his interest in the Far East, he was invited by a group of Japanese businessmen, with the support of the Emperor, to visit Tokyo to discuss the building of what would be known as the Imperial Hotel, where visiting dignatories could be entertained and, on occasion, members of the Imperial household. He arrived, accompanied by Mamah, and secured the commission. Wright was already a well known Western architect but the trip turned him into a world-famous figure – a condition which happily coincided with his own view of himself. On a later visit to Tokyo to oversee progress on the Imperial Hotel he was accompanied by Miriam Noel, a sculptress, who, leech-like, attached herself without invitation. Initially, and curiously, Wright accepted her attentions and even more curiously, when he finally obtained a divorce from Catherine, who by that time wished to marry someone else, he actually married Miriam. Although she left him soon after the marriage, she continued to harass him with threats and lawsuits for several years, disrupting his work and undermining his health.

During the First World War, Wright made a number of trips to Tokyo to monitor progress on the Imperial Hotel which was not in fact finished until 1922. These trips were usually made from California where he was involved in a series of seven houses and had made designs for at least another 37 projects. The first of the built houses was for Aline Barnsdall, who was an important patron of the arts, particularly of the theatre and music. As a person accustomed to lavish living, and financially independent, the energetic oil heiress bought Olive Hill, in Hollywood, and determined to

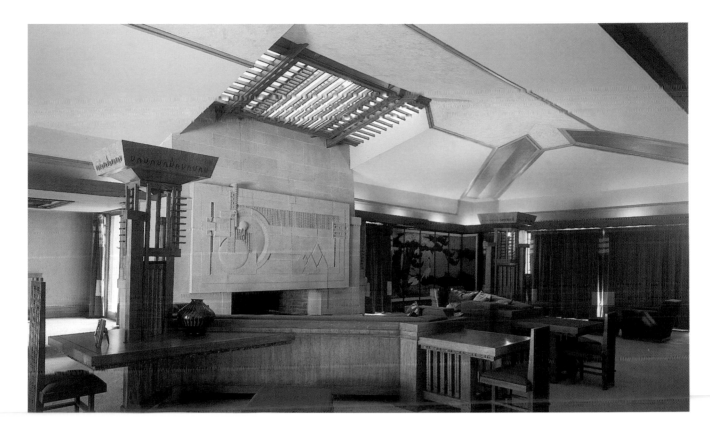

build a splendid and luxurious house there. She had met
Wright in Chicago and encountered him again on his return
from a Tokyo trip when she commissioned him, the result
being one of his most expansive house designs. It became
known as the 'Hollyhock House' because of the carved,
abstract hollyhock design with which it was embellished.
Wright completed a small number of other Californian houses
using a system which he called 'textile block' construction.
This consisted of cast concrete blocks, their surfaces modelled
to provide a rather more attractive finish than plain concrete.
Since the blocks were 'knitted' together with steel rods, the
name is not inappropriate. The first and most notable of these
was for Mrs George Madison Millard and is known as 'La
Miniatura' (plates 40 and 41). Three others were for Dr John
Storer (plates 42 and 43), Charles Ennis (plates 44 and 45) and
Samuel and Harriet Freeman (1924).

Wright's mother died in 1923 and the next year Louis
Sullivan, reconciled with Wright after a 20-year estrangement,
died in near poverty and professional obscurity. Wright had
held them both in great affection and reverence and their
deaths, not surprisingly, caused a deep melancholy and a sense
of personal isolation amounting almost to despair. It was at
this time that his life was again to undergo a dramatic change.
He met Olga Lazovich, a Montengrin recently divorced,
energetic, young, ambitious and talented. Wright was attracted
and she reciprocated, but the baleful Miriam was still his wife
and it was not until he succeeded in gaining a divorce from

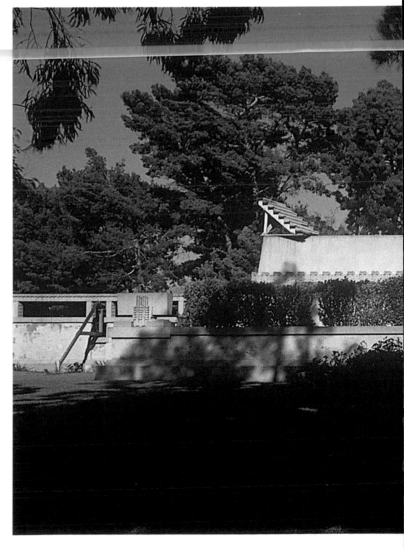

PLATES 38 and 39 opposite and below

Aline Barnsdall House (The Hollyhock House), Los Angeles, California 1920

On one of his trips through California during his supervision of the construction of the Imperial Hotel and a few other houses that he designed during the time spent in Tokyo, Wright met Aline Barnsdall whom he had known in Chicago. He made for her a number of designs, including her own house and two others, all completed before the Imperial Hotel, as well as project designs for a range of shops, small houses and a theatre. The Barnsdall theatre was a particularly ambitious project in poured concrete to sit upon the Barnsdall site on Olive Hill. Unfortunately, none of these projects came to fruition but they did provide work at a testing time. The Hollyhock House carried many of the ideas intended for the theatre, including the use of poured concrete for decorative details. Although not carried through entirely to Wright's intentions, it is one of the most majestic and expensive houses he made during the early period. It was constructed in poured concrete

which Wright abandoned for the textile block method for the other Californian houses. The design for the house was completed by 1917 and the influence of the Imperial Hotel design is evident. More significant, however, is the Mayan influence and the southern Mission tradition in California. The plan has a centralized but asymmetrical design and the elevations carry no residual Prairie Style characteristics. Aline Barnsdall contributed at least one important element to the design when she insisted that a California house should be divided equally between interior and exterior uses so that the roofs and the central atrium could be used in favourable weather. Much of the interior decorative design was created by Wright himself and includes the 'hollyhock' abstraction. He was explicit about the universalist intention of these designs, including earth, air, fire and water symbolic and literal elements. Aline Barnsdall was, perhaps justifiably, exceedingly irritated by Wright's enforced absences from the site and Wright arranged that Rudolph Schindler, then at Taliesin, should become the site manager and thus use his considerable charm to calm her fears.

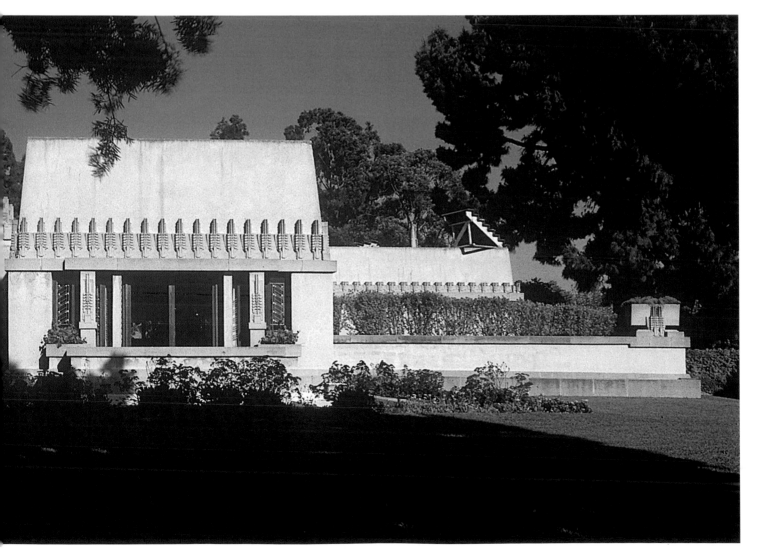

PLATES 40 and 41 below and opposite

Mrs George Madison Millard House (La Miniatura), Pasadena, California 1923

Extravagantly, Wright declared in his autobiography that he would prefer to have been responsible for 'La Miniatura' rather than for St. Peter's in Rome. It is, however, a measure of his vision of himself and his towering ambition that he should have compared this modest house with Michelangelo's masterpiece. Mrs Millard had already lived in a house designed for her husband by Wright and when he explained his new textile block system and suggested that he should make a new house for her, she was happy to give him a free hand. The simple block shape of the main structure is only enlivened by the cast decorated concrete block welded into a unit by the use of steel rods. Although Wright had intended to design the furniture and fittings, this did not happen as Alice Millard was an antique dealer who filled her house with her stock to somewhat incongruous effect. Since the house was located in a ravine, it was taller than was usual with Wright and the entrance was on the side at second-floor level. The living room is the height of two storeys which are related to two storeys of bedrooms to the rear, while the dining room and kitchen only are on the lower ground floor below the living room.

It is important to recognize the originality of the design apart from the effect of the decorative blocks. Its arrangement of masses is similar to the designs of the European contemporary scene as expressed in the work of Le Corbusier and the architects of the Bauhaus, notably the Gropius staff houses. Gone are the characteristics of the Prairie Style, the strong horizontal emphasis, and the concentration on a 'craft' look.

her that he was able to marry Olga, usually known as Olgivanna. She remained with him for the rest of his life, providing a settled base and a stable family environment.

The year 1925 was a good year for Wright, despite another serious fire at the rebuilt Taliesin II. His reputation in Europe was enhanced by the publication in Germany of a lavish book on his work, written by J.J.P. Oud, an architect member of the important modern Dutch art movement, De Stijl (The Style) and prominent in the formation of the European 'International Style'. More importantly for the Wrights, Olgivanna gave birth to a daughter, Iovanna; but characteristically, the good times were not to continue. In 1926 and 1927, still harassed by Miriam, Wright was again reduced to near despair. He was short of money and saw no other solution than to sell his treasured Japanese prints and other valued personal possessions, was nearly dispossessed of his home, and was forced into hiding with Olgivanna and their daughter.

They were saved by their friends – mostly satisfied clients – and Frank Lloyd Wright Incorporated was formed to assume his liabilities and to pay him a salary. The rebuilding of Taliesin II had continued and what was effectively a new house was completed to become known as Taliesin III (plates 46 and 47). In 1927, Wright was offered a large project by Dr Alexander Chandler to built an extensive complex of offices, a hotel and houses at Chandler, Arizona known as San Marcos-in-the-Desert. Many elaborate plans

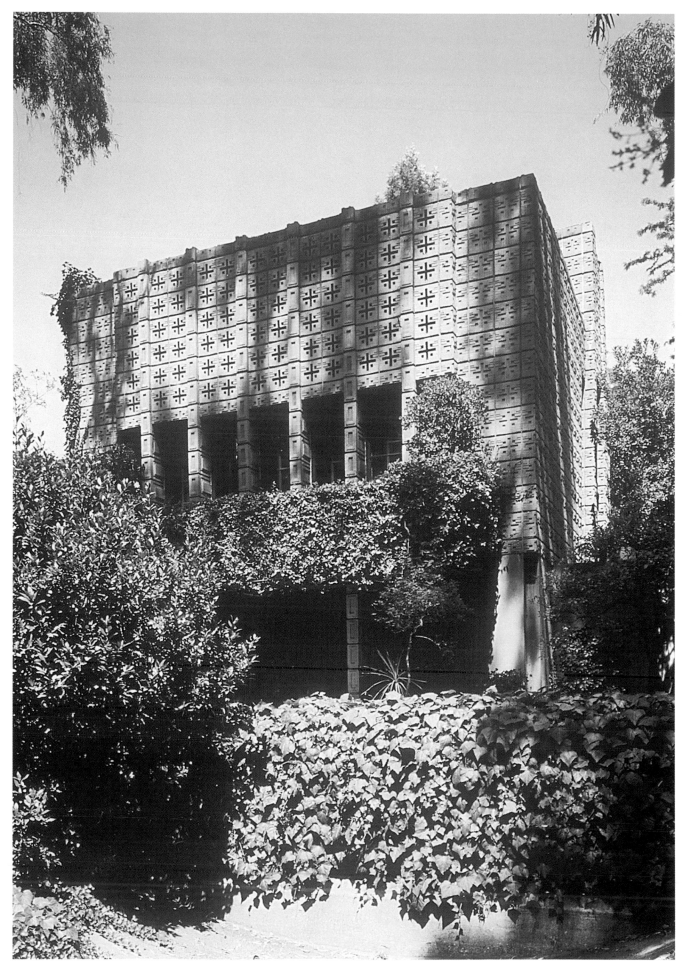

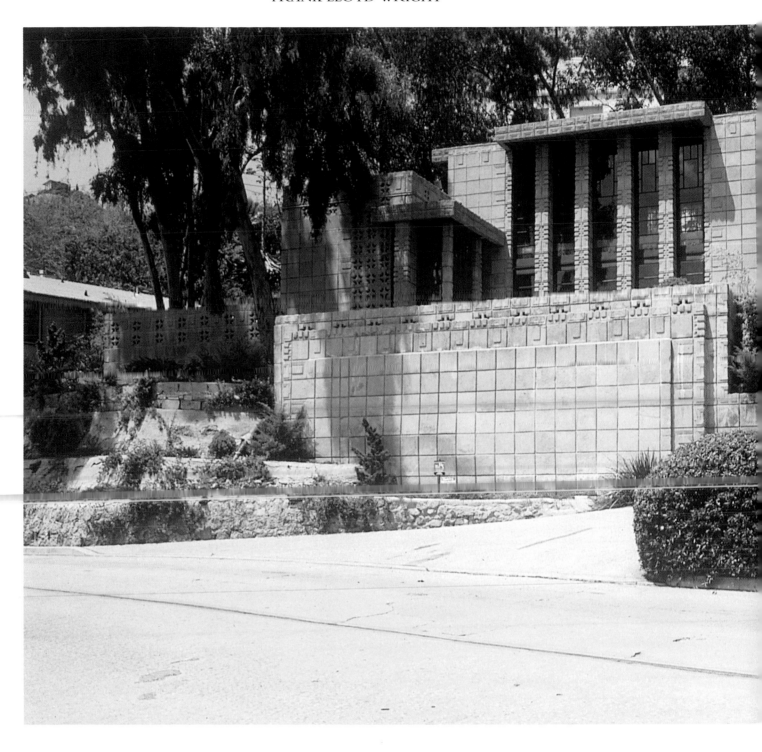

PLATES 42 and 43 above and opposite
Dr John Storer House, Los Angeles, California 1923

Wright constructed four textile-block houses in California and the Storer House is located on a hillside site off Hollywood Boulevard. The house was allowed to deteriorate but has now been restored and provides a good opportunity, both externally and internally, to assess the effect of the decorative qualities of Wright's textile-block innovation. It is perhaps in the interior that the impact is most dramatic. We are accustomed to expressing the structure of domestic building only on the exterior and to use the internal wall surfaces for personal expressions of taste. Wright wished the linkage of interior and exterior to be both visually evident and to have the unity of his own design dominating. In these houses, the interior is as Wrightian as the exterior. In the Storer House this is an obvious quality. Not so apparent is the sense of flowing space found in the earlier houses, such as the Robie House (plates 30 and 31). Part of the reason is the sloping site which necessitates a variety of levels which, while offering dramatic and effective views from 20-ft (6m) high windows, isolates elements of the house on the separate floors.

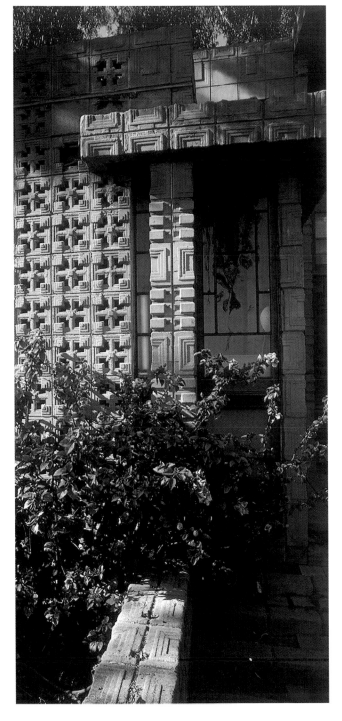

were prepared and Wright built temporary headquarters nearby, known as Ocotillo Camp, to control the building of San Marcos. The Great Depression of 1929 prevented the project from being carried through and Ocotillo Camp became the model for Taliesin West (plate 55), built at Phoenix, Arizona, that became the centre of Wright's work for the rest of his life, has become synonymous with the Wrightian legend and is the headquarters of the continuing Wright Foundation.

Around this time, Wright's divorce from Miriam was made final and he was free to marry Olgivanna. Together with their daughter, Iovanna, and Olga's daughter by her first marriage, Svetlana, they went to live at Ocotillo Camp and Wright worked on other large and visionary projects never to be realized, partly as a result of the Great Depression. Throughout this time, and prompted by Olgivanna, Wright was writing and lecturing; but for five years, nothing that he designed was erected. Despite the enormous repution of his early work, the success of the design of the Imperial Hotel in withstanding the great Tokyo carthquake, and the influence in Europe of the Wasmuth portfolios, his career, at the age of 67, seemed

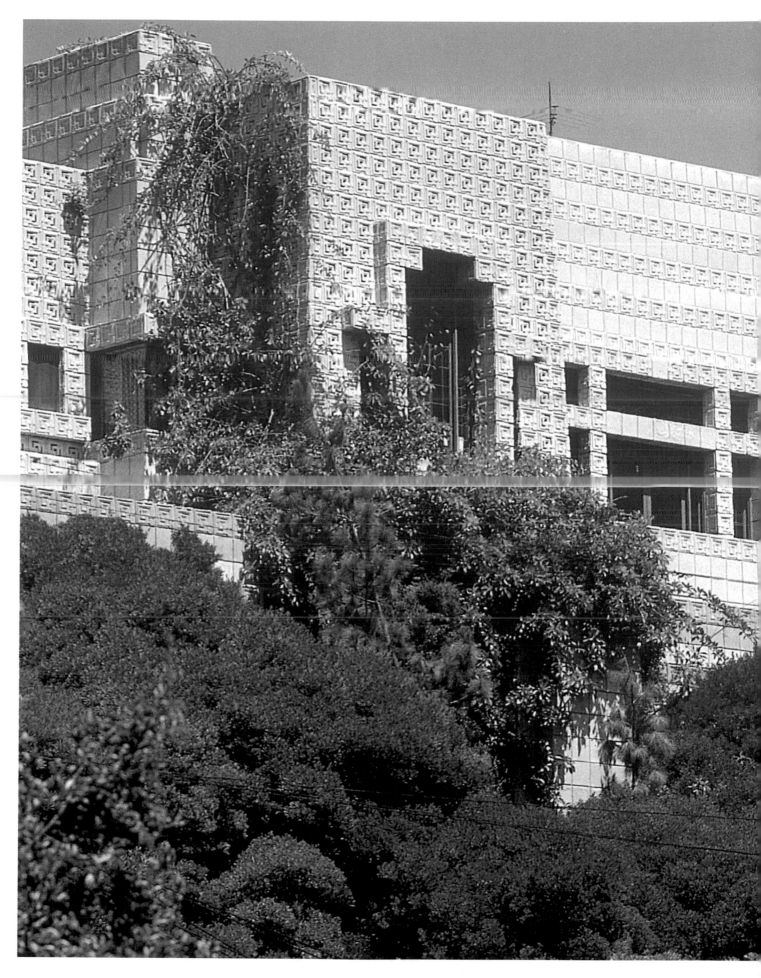

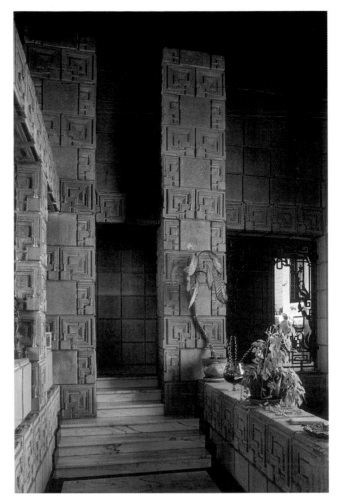

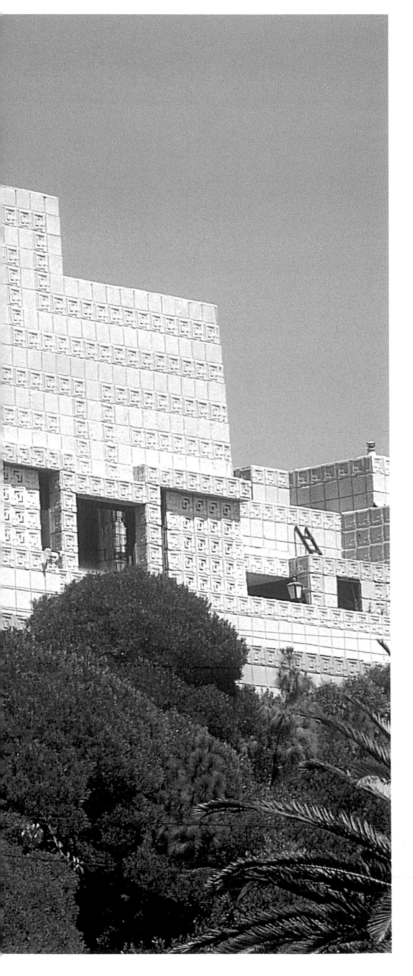

PLATES 44 and 45 left and above
Charles Ennis House, Los Angeles, California 1923–24

Located in the Los Feliz Hills, this is the largest of the Los Angeles textile-block houses, and the effect of the massive structure is suggestive of a Mayan temple. Wright's own personal favourite among the Los Angeles houses, the Ennis House is set high on a full-length retaining wall and has a wide terrace. Over 20 different patterns and shapes of concrete block were used, providing 80 different combinations of use in the house. It is an imposing sight, even more reminiscent of the modern European style than the Storer house. It was not completed to Wright's original design and friction developed between the Ennises and Wright's son, Lloyd, also an architect who had been put in charge of operations by his father. This led to the Ennises finishing the project themselves without Wright's agreement. The plan is linear rather than cruciform and the largest single space is the dining room at the centre of the house, with a long living room contiguous with it. A guest suite and bedrooms are arranged around the long loggia: it has to be admitted that it does not carry the sense of domestic unity usual in Wright's houses.

PLATES 46 and 47 right and opposite below
Taliesin III, Spring Green, Wisconsin 1925

The rebuilding of the original Taliesin, after the tragic events related on page 41 et seq., resulted in a new house, Taliesin II, which in turn was destroyed by fire in 1925. The third Taliesin became Wright's centre of operations for the rest of his life, over the years becoming an increasingly extensive complex of buildings. The first linear building with stops at each end was expanded in all directions and included a large draughting studio and a gallery, quarters for Mr and Mrs Wright and their children, a music room, services and an extensive hill garden.

ostensibly at an end and that nothing further of architectural significance could be expected of him.

Although his autobiography, first published in 1932, was a great influence on his own students at Taliesin West, Wright ceased to be the inspiration he once had been as the focus of the avant-garde turned towards the European architects who had begun to establish what has come to be known as the International Style. In America, interestingly, the International Style had been identified and given authority by an exhibition in the Museum of Modern Art, New York, also in 1932, and by H.-R. Hitchcock and Philip Johnson's book, *The International Style; Architecture Since 1922*, which accompanied it: but Wright was not included in it. This is surprising since Hitchcock was a great admirer and student of Wright's, having written the authoritative study of his work, *In the Nature of Materials*, still admired today for its scholarship. The relentless movement towards the dominance of this new style was being given added impetus by an influx of European architects. The most influential in this context are Walter Gropius, the first director of the Bauhaus at Weimar and Dessau, and Mies van der Rohe, its last director when the Bauhaus was closed in 1933 by the misleadingly named National Socialists, Hitler's supporters in his rise to power. One of the earliest émigrés was Rudolph Schindler, drawn to America through Wasmuth's publication, who worked for Wright on the Hollyhock House and was architect of the Lowell Beach House, Newport Beach, California (1925–26), one of the first and highly influential examples of the International Style in the United States.

Despite his towering reputation, Wright had become marginalized in the early thirties, but his creative, original and forceful personality was as strong as it had ever been and in his new, settled family environment he was able to design some of his greatest work, enabling him to return to the centre of the architectural stage in 1936. Between 1934 and 1936 he had been working on four different commissions which were to become world-famous, including what is probably his best known building, 'Falling Water' at Bear Run, Pennsylvania, for Edgar J. Kaufmann (plates 48–50). The other three commissions were the Johnson Wax Administration Building, Racine, Wisconsin (plates 51 and 52); the Hanna House (plate 54) and the first Jacobs House (1937). This last was the first of a series of inexpensive houses known as Usonian (United States of North America) and their commission initiated what is perhaps the most intensely creative period in Wright's entire career. Settled in his marriage, he was able to concentrate on his work, preside over the Taliesin Fellowship and influence his students, his disciples. The word is not used lightly. He had become an almost mystical figure by the end of his life,

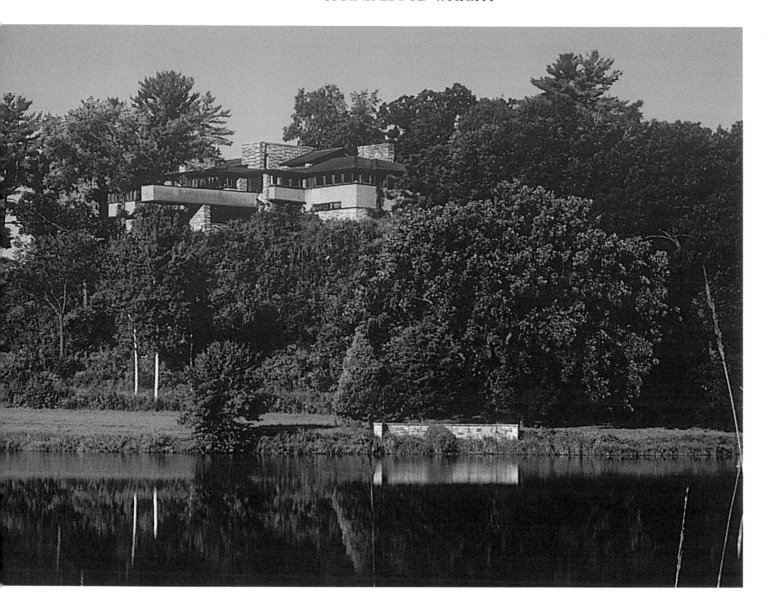

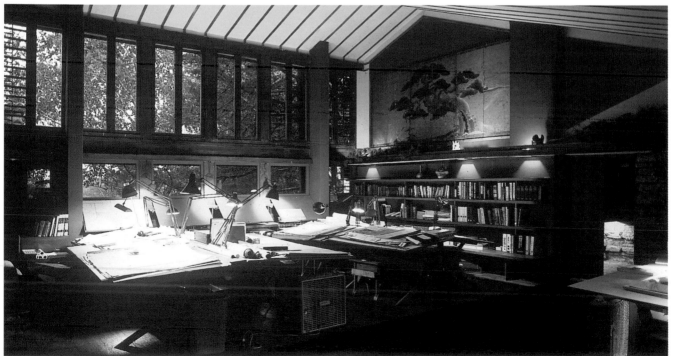

PLATES 48 right, 49 and 50 (pages 56 and 57)

Edgar J. Kaufmann Snr. House, (Falling Water), Bear Run, Pennsylvania 1936

Often described as the most famous house in the United States, the Kaufmann House, more familiarly known as Falling Water, immediately established Wright as a genius of modern architecture. Always an individualist, Wright had followed his own path successfully but without general acknowledgment. Indeed it was widely believed that the best of his career was over. Falling Water changed this premature judgement and heralded a new creative stage in his work. Although different in character, construction and intention from the work of his European contemporaries, two of the most important of whom had recently arrived in the United States, Mies van der Rohe and Walter Gropius, it was evident that Wright had a command of modern aesthetics and technology of equal significance and possibly more attraction. One of the most seductive qualities of the house, within its highly romantic sylvan setting, is its sense of perfect appropriateness in its context and

continued on page 56

was convinced of his own importance as an architect, being now able to choose his own commissions.

During the thirties and fifties he designed a number of religious buildings including the Anne Pfeiffer Chapel on the Florida Southern College campus at Lakeland, Florida (1940), for which he also designed the whole complex although this was not fully carried out to his design; the Unitarian Church, Shorewood Hills, Wisconsin (plate 60); the Beth Sholom Synagogue, Elkins Park (plate 61), and the Annunciation Greek Orthodox Church, Wauwatosa (plate 62). His last designs were completed after his death, including the world-famous if controversial Guggenheim Museum (plates 64 and 65) and the very large Civic Center complex of Marin County, San Rafael, not completed until 1966 (plates 66 and 67).

Frank Lloyd Wright died on 9 April 1959. He left a legacy which remains the most significant and representative of American architecture. There are many aspects of his work which emphasize his originality and creative acumen, but the one element that might perhaps be offered as his essential contribution is that he utilized an inventive technology for a personal artistic aesthetic that has influenced succeeding generations of architects to regard art, not as an adjunct to an effective functioning technology, but as the basal force inspiring effective architectural form and present in the work of architects ranging from Louis Kahn to Frank Gehry.

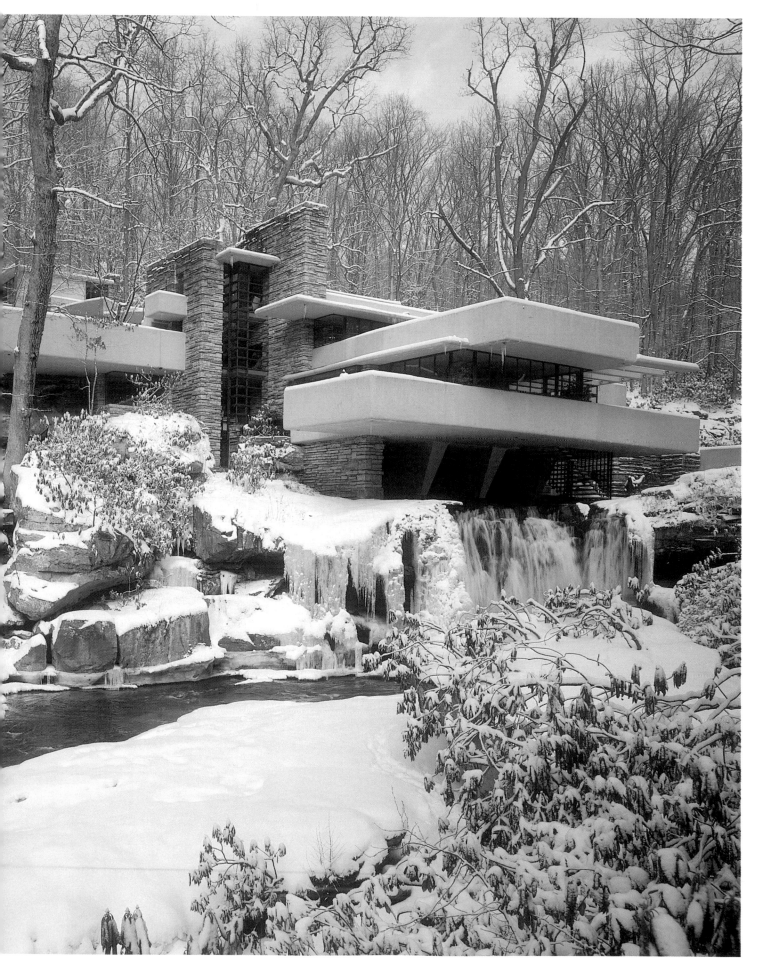

continued from page 54

almost overbold technology. The cantilevered, balconied terrace running across the length of the house is a tour de force; linked and balanced by the natural stone support and tower, it juts over and obscures the small stream and waterfall. The gentle sound of the soughing trees and the small waterfall under the balcony provides a haven of peace in a delightful setting. The whole structure of the complex is executed with panache and imagination and as an architectural statement of a modern aesthetic for domestic buildings there is none finer or more stimulating to the imagination. In its setting, it carries overtones of the romantic poetry of Wordsworth and of Rousseau's call for the natural life of the 'noble savage'. It is interesting to note that, for Wright, concrete remained an essentially unsuitable material; a 'conglomera' that offered 'little quality in itself'. Astonishingly, he had originally intended to cover the concrete in Falling Water with gold leaf, but dissuaded by Kaufmann, settled for apricot paint.

Edgar Kaufmann Snr. was inspired by his son's visit to Taliesin to join the Fellowship, and his subsequent enthusiasm over Wright's achievements, to commission him to build the house as a weekend retreat, enabling him to escape from the business world into rural peace. He had envisaged a 'log cabin' type of structure, related to Wright's famous Prairie houses and using local materials – very much in keeping with Wright's declared thinking. The design proposed by Wright came as a considerable shock to him but he was eventually, after some strained discussions, persuaded by Wright that it should be done his way or not at all. The result is a national monument and certainly the most famous private dwelling in America. After Edgar Kaufmann Jnr. inherited it, he gave it to a nature conservancy organization and its setting and character are thereby preserved.

As one of the earliest of such cantilevered structures and with no great experience of the long-term qualities of reinforced concrete, the house has encountered some structural problems in the essential linking of the building to its solid rock base. The house is on three levels, the main floor consisting of a single flowing area from balcony to the kitchen and services, the upper floor of bedrooms, bathrooms and two terraces, and the smaller top floor of one bedroom, a gallery and a terrace. The side elevation shows the great extent to which the main and upper floors are cantilevered over a void.

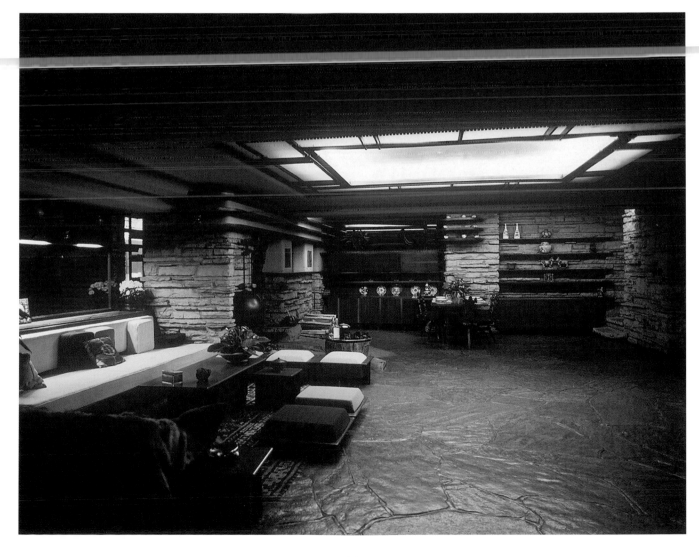

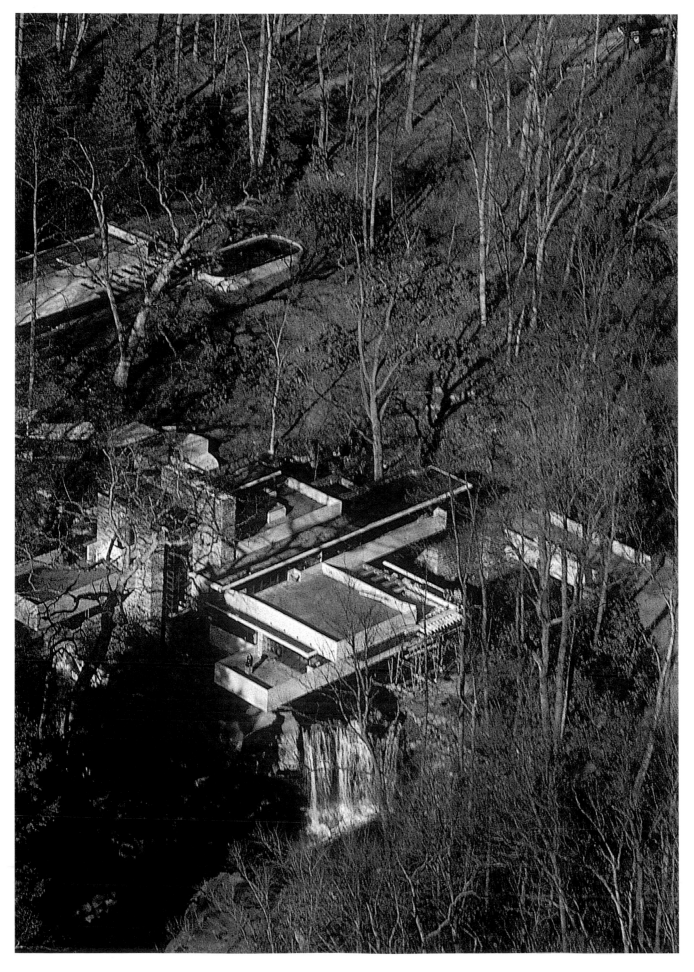

PLATES 51 and 52 below and opposite

S.C. Johnson and Son Administration Building, Racine, Wisconsin 1936

Wright's return to great creative energy was not confined to the domestic scene and, coterminous with Falling Water, he designed the largest office structure which was actually built since the Larkin Building of 1904. Although incorporating many of the ideas of the earlier building, most notably the sensation of been insulated or protected from the outside world, the effect of this structure is much more sophisticated and, as Wright described it, 'streamlined'. Externally a great expanse of red brick walls, unfenestrated, and broken only with entrances, it surrounds the rectangular site, the complex being illuminated by skylight Pyrex tubing and interior glass walls through which the light penetrated with a soft efficiency, much enjoyed by the employees. Wright designed the furniture, much of it painted metal, as well as night lighting fittings of unusual sculptural forms. The most dramatic features of the interior were the mushroom columns in the main concourse housing the administrative desks. The fear was that the columns, which partially supported the roof structure and carried the concealed lighting, would not be sturdy enough. The columns were hollow and made of reinforced concrete which, from a narrow base, spread towards the mushroom top: when one was tested, it proved that it could carry the equivalent of 50 tons — over five times the weight it would be asked to carry. The research tower dominating the scene was added ten years later and its rounded corners, it has been suggested, echo the Johnson products themselves.

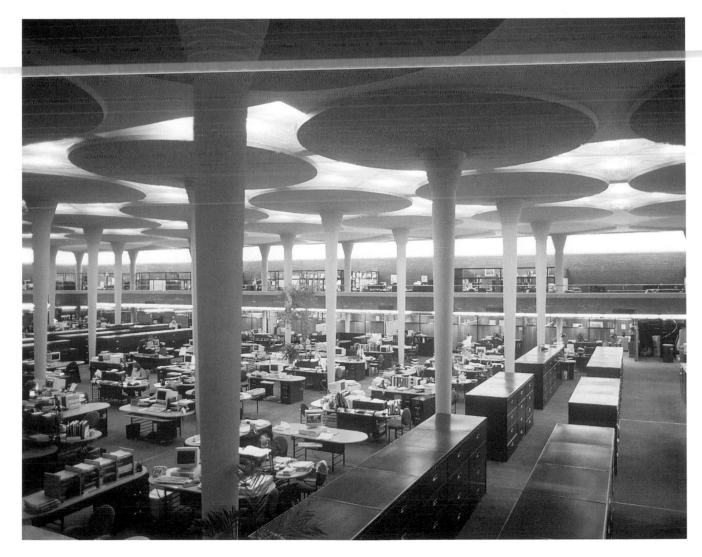

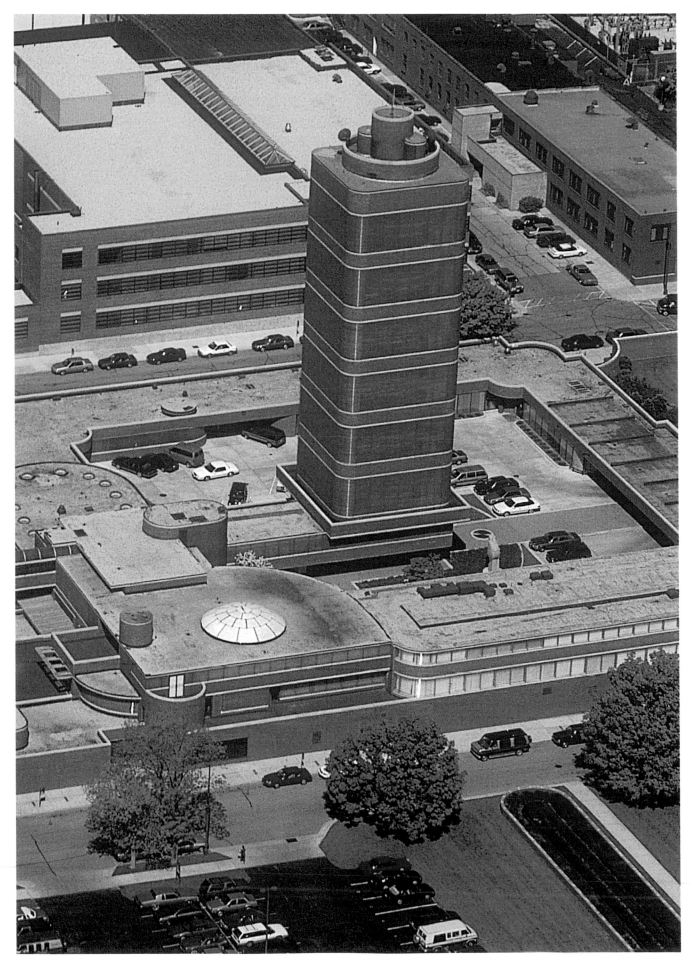

PLATE 53

Herbert F. Johnson House (Wingspread), Wind Point, near Racine, Wisconsin 1937

One of the larger of his mansions and designed on a plan reminiscent of its familiar name, 'Wingspread' was for Wright's Johnson Wax client and although an impressive, massive house, it is rather more conspicuously extravagant than his most admired buildings. It is constructed around an enormous central chimney and the living quarters comprise a large hall, music room, library and dining area. Each wing serves a different function: master rooms in one, children's playroom and bedrooms in another, guest rooms and garages in the third and servants' quarters and services in the fourth. The site is composed of shallow ravines and Wright has taken full advantage of these to give a floating on waves sensation for the building and, since the core mass rises above the building suggesting a ship's bridge, the whole complex gives a positive appearance of a stately landship. The house is so large that it is no surprise to learn that it later became a conference centre.

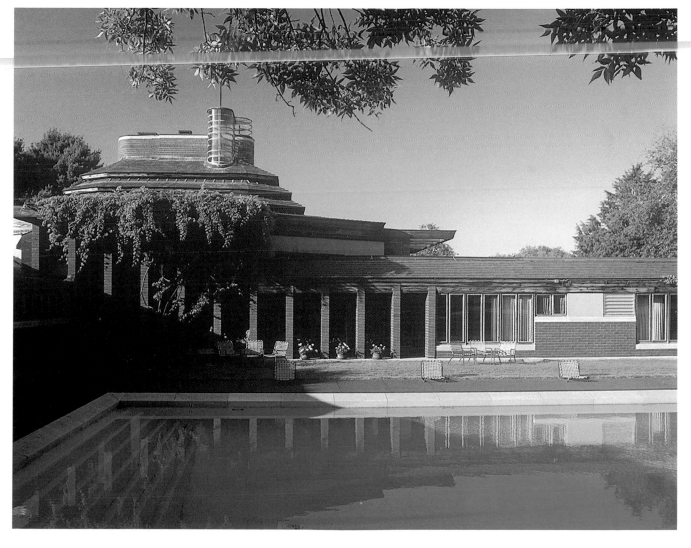

PLATE 54

Paul R. Hanna House (The Honeycomb House), Palo Alto, California 1937

The Hanna House was the last of the four initial creative developments in Wright's oeuvre during the 1930s and began a new preoccupation with geometrical form. Wright's work had shown an acceptance of the rectangular basis of structural design and only a few examples of his use of other relationships occur – projecting triangular window forms, for instance. During the 1930s he had begun to be interested in other geometrical shapes – the hexagon, circle, triangle – as possible architectural applications. In the Hanna House, as the Honeycomb soubriquet indicates, the hexagon is employed within an essentially rectangular base.

The Hannas, Paul and Jean, were young academics who had

visited Taliesin and Japan and were already familiar with Wright's work. When Paul was given a post on the faculty of Stanford University in 1935, they asked him to design a house for them. Well able to imagine the nature of such a venture, and aware of the power of Wright's personality, they were nevertheless, in their youthful enthusiasm, able to cooperate with him in a highly successful solution which opened new possibilities for Wright and gave inspiration to others as knowledge and admiration of his new radicalism became widespread.

The hexagonal plan was not without its problems for the builders, since the 120° angle needed was unfamiliar, and necessitated different brick and wood treatment on angles. In keeping with the building, Wright also designed furniture and fittings. The house is now owned and maintained by Stanford University.

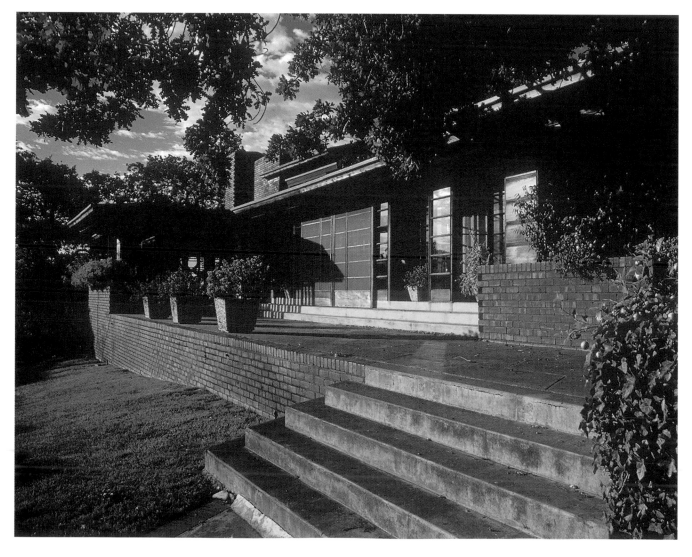

PLATE 55

Taliesin West, Scottsdale, near Phoenix, Arizona 1937–59

The fourth and last Taliesin was the final outcome of a programme that began with the project at Chandler in Arizona, San-Marcos-in-the Desert, designed for Dr Chandler but killed off by the Great Depression of 1929. In preparation for it, Wright had constructed Ocotillo Camp, a temporary headquarters near the site at Salt Range, Arizona. While working there, Wright had acquired a deep love for the desert and the quiet peaceful isolation it provided: Taliesin West was the permanent structure that replaced Ocotillo. At Ocotillo, Wright had experimented with new materials in a new environment and his interest in different forms, derived from simple or complicated geometrical shapes, also had its beginning there. All these elements were to some extent incorporated in the new headquarters.

The hexagon angle used in the Hanna House was included within a strong directional and rectangular framework, providing a varied vista of the single-storey building. A variety of materials were used, including the red desert stone, concrete, wood and canvas. The complex contained workshops, study, office, apprentice's court, sports and shop areas and accommodation for the Wrights. Externally, there was a triangular pool, a sunken desert garden and the luxuriant desert flora provided a decorative foil for the firm horizontals of the buildings.

Wright's habit of redesigning and extending a building after it was apparently completed has led to extensive alterations to the original plans as outlined during Wright's lifetime and the complex became the centre of the Taliesin Fellowship; as the apprentices qualified and dispersed, the name Taliesin became even more famous than it had been during the first Taliesin period. The building itself is evidence of the individual contribution that Wright made to modern architecture outside the pattern set by the International Style.

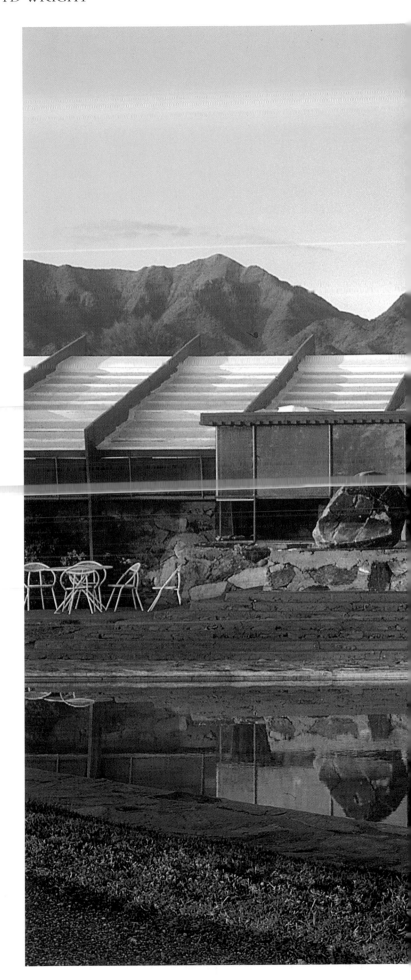

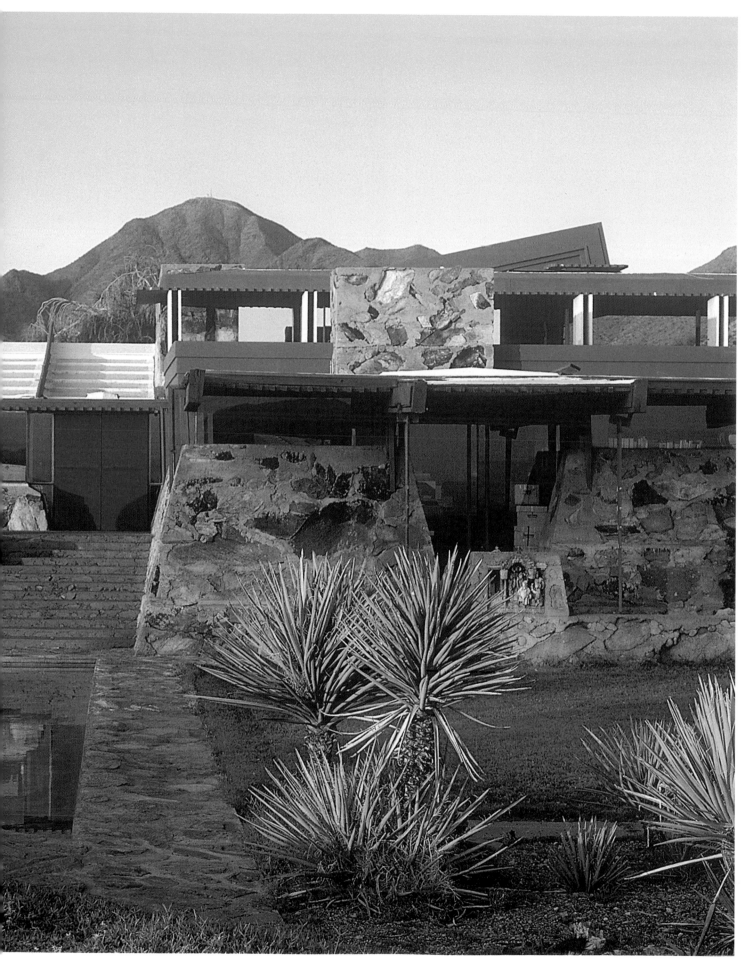

PLATE 56 right

Katherine Winkler and Alma Goetsch House, Okemos, Michigan 1939

A group of professors at the University of Michigan planned a staff complex of seven Usonian houses but the only one completed was the Winkler/Goetsch House which was on a slightly more lavish scale than the original design. It is considered to be the most successful of Wright's houses in the genre. Set on a concrete base on a level site, the single-storey house has something of the strong directional quality of the Robie House (plates 30 and 31), but on a much smaller scale. The overhang of the flat roof and the redwood walls provide a foil to the brick and concrete while the grouped fenestration offers strong verticals to balance the horizontal emphasis.

PLATE 57 below

Lloyd Lewis House, Libertyville, Illinois
1940

Wright continued to create innovative designs for private houses as he had throughout his career. The small-scale Usonian houses followed a similar pattern, but when given a freer hand Wright continued to produce surprise solutions. The Lloyd Lewis house is described by Hitchcock as having the 'handsomest and most harmonious furnishing of any of Wright's later houses'.

The house is built on the banks of the Des Plaines river and is raised above the river bank on brick piers to avoid rising floods which gives a more imposing effect than is usual with what is actually a one-storey house. There is a cantilevered concrete terrace, faced with wood, on the raised main floor and the construction, including the base, is of brick.

Lewis was the editor of a local paper whom Wright described in his autobiography as his 'own dear friend' and Lewis and his friends certainly enjoyed the house. One visitor, Alexander Woollcott, claimed that the house 'uplifts the heart and refreshes the spirit'. What more can one ask?

PLATES 58 and 59 below and right

Herbert Jacobs House II, Middleton, Wisconsin 1946

Since the first Jacobs House of 1937, the family had increased so that the original house had become inadequate. They still had modest means and required an inexpensive house and, as was previously the case, they did much of the work themselves. Wright himself was at this time still preoccupied with exploring geometrical forms in architectural design. Here he used the circle, what he described somewhat romantically and not entirely explicitly as a 'solar hemicyclo'. The house and a sunken garden fronting it formed a circle and were set into the top of a small hill. The house was of a single storey and open plan with the main living areas opening onto the garden. It does not seem to have been an entirely satisfying exercise for Wright and was not directly repeated, although other later works include circular or partly circular elements.

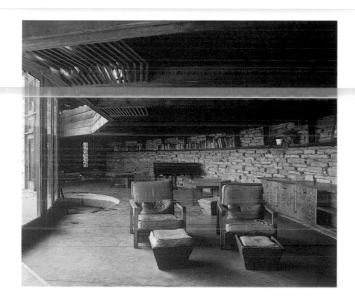

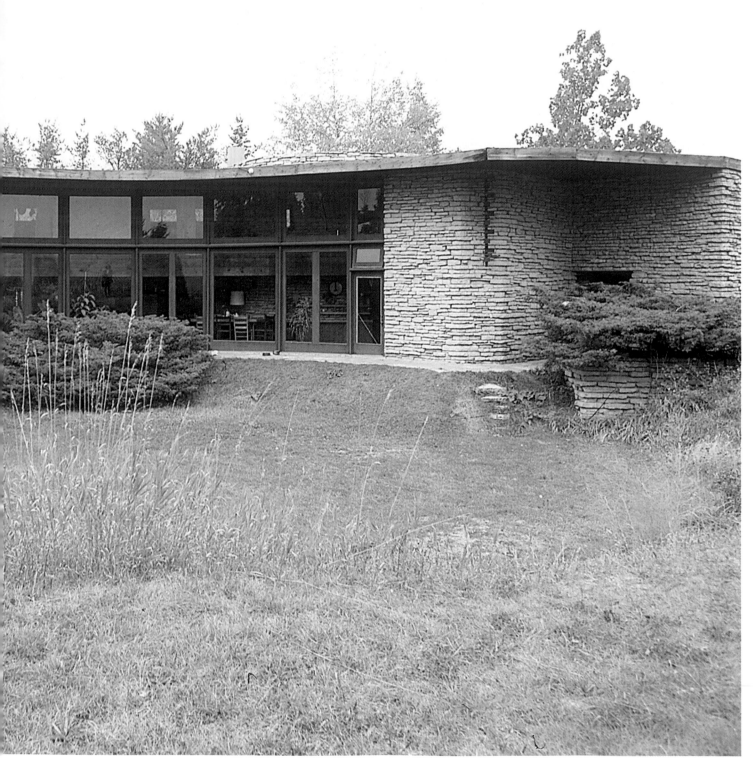

PLATE 60 below
Unitarian Church, Shorewood Hills, Wisconsin 1947

PLATE 61 opposite
Beth Sholom Synagogue, Elkins Park, Pennsylvania 1954

When Wright designed the Unity Temple (plates 26–29) in 1906, he was providing a setting for the practice of his own faith and was therefore familiar with its needs. Subsequently he designed a chapel for Florida Southern College for a similar, if not identical, Protestant ethic. In 1947 he designed another Unitarian Church at Shorewood Hills where he applied his new interests and experience to produce a more externally dramatic and aggressive building which was felt, however, to induce a feeling of great calm and reverence, highly conducive to the Protestant form of worship and similar to that experienced by the worshippers in the Unity Temple 40 years earlier. The plan interlocked two triangles of different areas, while two wings to the rear provided a Sunday School and the various service facilities and storage. The huge sweeping roof, copper-covered, seems to epitomize the strong missionary zeal and thrust of the faith.

Wright was to design two further buildings for different faiths and it is interesting to note that he believed himself to be perfectly capable of producing an effective architectural solution for a faith which was not his own.

The synagogue was constructed with the close cooperation of the Rabbi and resulted in a pyramidal structure of glass, aluminium and steel, constructed on a concrete frame. This design was adapted from an earlier design Wright had made in Spring Green, an enormous project never realized which would have taken the form of a great wigwam of steel to house all religious denominations in various chapels and temples. In a sense, this reflects a feeling that Wright believed such a shape to be appropriate for most faiths – particularly the Hebrew.

The tent-like interior is possibly suggestive of a nomadic faith and the centre of worship, approached by a flight of stairs, is directed towards the Ark of the Covenant. The seating for 1,000 worshippers is in a number of separate blocks at different angles, possibly representative of the different tribes, and the interior contains decorative and symbolic designs made by Wright under the instruction of the Rabbi. The roof is of translucent glass which by day produces a soft internal light, while at night allows the whole structure to glow from the interior illumination.

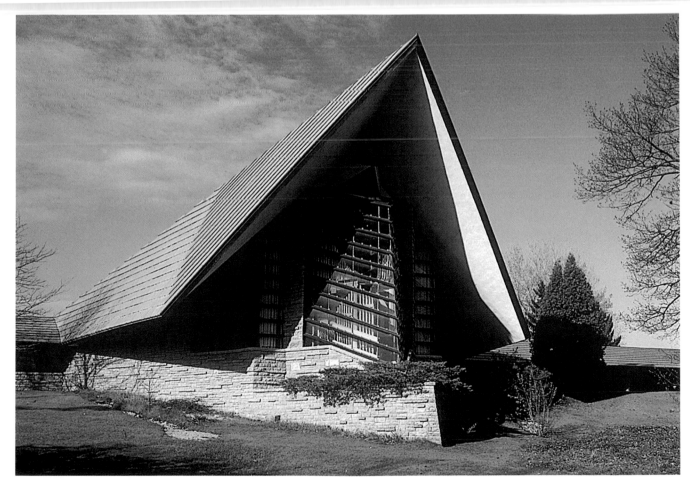

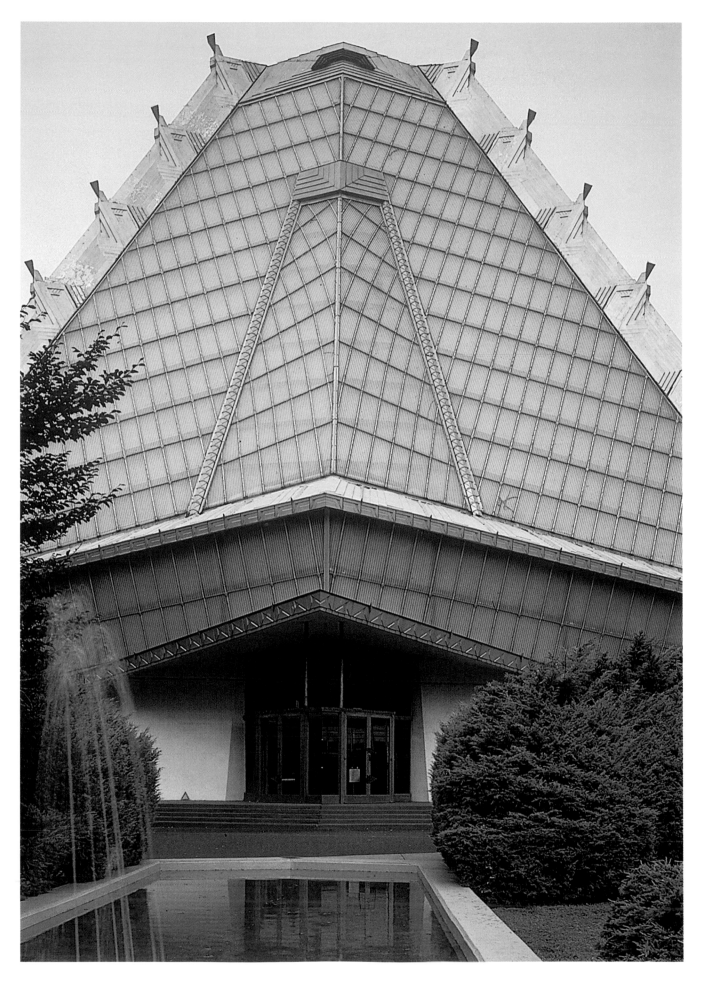

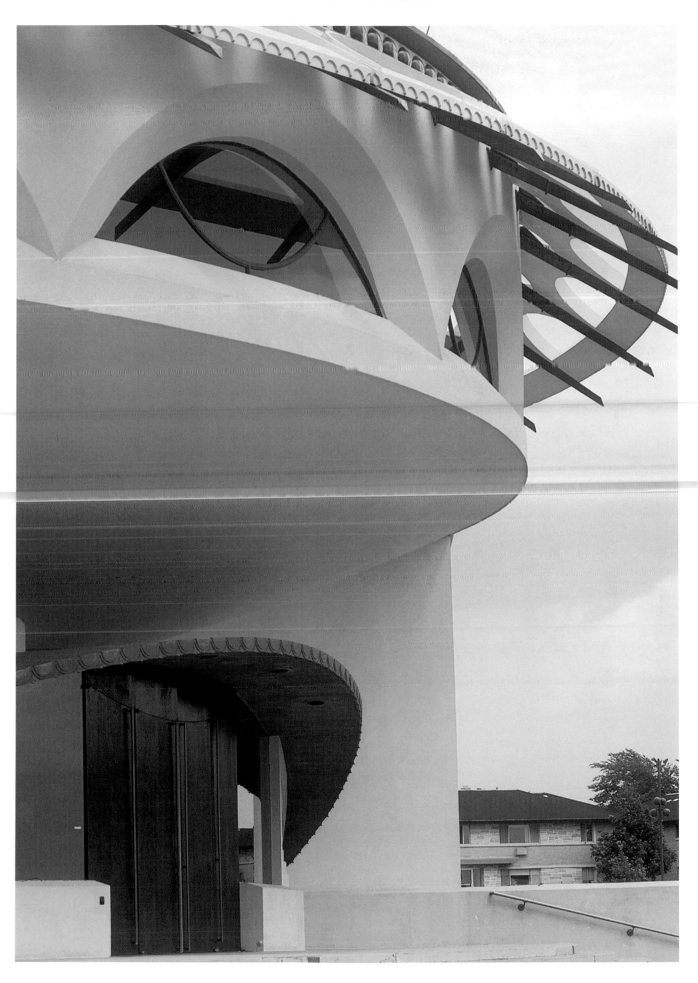

PLATE 62 opposite

Annunciation Greek Orthodox Church, Wauwatosa, Wisconsin 1956

Wright's enthusiasm for geometric forms is given an historic justification in this Church where the circular shape he adopted echoes that of the domed early Greek cruciform churches. Wright's dome is shallower than the Byzantine models and is rather more firmly wedded to the earth. The circular motif is repeated internally and externally to create, as do the circle and the sphere, a sense of containment and richness of form. There are different qualities in the late works from those found earlier; an incautious romantic elaboration of design ideas, sometimes effective, sometimes 'over the top'. There is no doubt, however, that Wright's creative and exploratory zest continued to the end of his life.

PLATE 63 right

Harold C. Price Company Tower, Bartlesville, Oklahoma 1952

Harold Price's original intention, with the Johnson Wax complex in mind (plates 51 and 52), was to have Wright design for him a similar office building. As usual, Wright did the unexpected and produced a high-rise tower as the office headquarters for Price's oil company. As will have been realized from some of the work already discussed, Wright often returned to previously unrealized designs which had pleased him when presented with a new commission. In this case, the inspiration was a desire to explore further the taproot solution that he had proposed for his unexecuted St Mark's Tower, in 1929. For Price, he produced a combined mixed-use office and apartment tower. The apartments were a way of successfully adding height to the building he had in mind, although they were not part of his brief. The whole was crowned with a sculpturally designed top, reminiscent in idea, but not in execution, of Le Corbusier's Unité d'Habitation being built at Marseille at the same time. Wright described the tower as a composite shaft of concrete, rising through all the floors which were cantilevered to it like the branches of a tree. Despite a number of project designs for skyscrapers, the Price Tower remains the only near skyscraper of Wright's that was actually built. Price was excited by the originality of the design and Wright and he became close friends, so much so that Wright acted as realtor for the apartments and constructed two houses for Price's family.

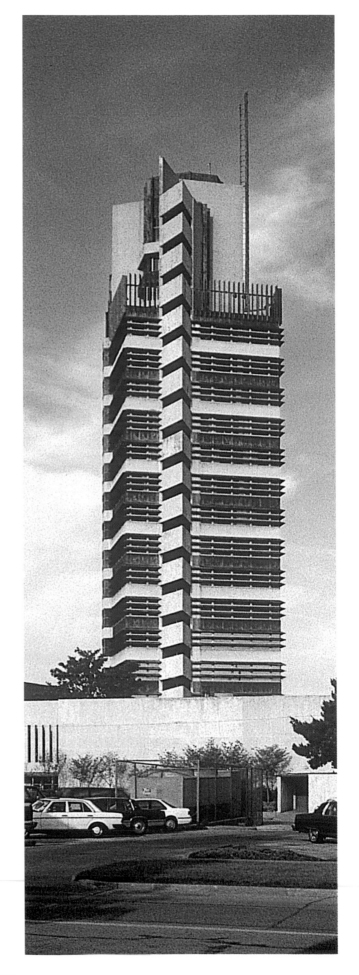

PLATES 64 and 65 below and opposite

Solomon R. Guggenheim Museum, New York City 1946–59

The extraordinary originality of the design and its location on New York's famous 5th Avenue has made the Guggenheim Museum one of the most recognizable building in the whole of 20th-century modern architecture. Its form is so incongruously at variance with the tall slab buildings that surround it that, as a structural form, it is a constant subject for analysis and argument. The form derives from Wright's notion that a continuous descending ramp would be an appropriate basis for the examination of works of art. The idea

of a ramp of this kind had been in his mind for many years and had been used by him in the Morris Gift Shop in San Francisco (his only work in that city), in 1948.

Wright's characteristic determination, self-confidence and inflexibility once his mind was made up, enabled him to drive the design through, although the work was not completed before his death. The special difficulties of constructing an inverted conical spiral were overcome and Wright had no doubts about the appropriateness of its form as a vehicle for viewing art. Others, and this includes the author, have found that the lack of horizontal flooring when viewing a rectangular painting causes an uncomfortable feeling of physical instability.

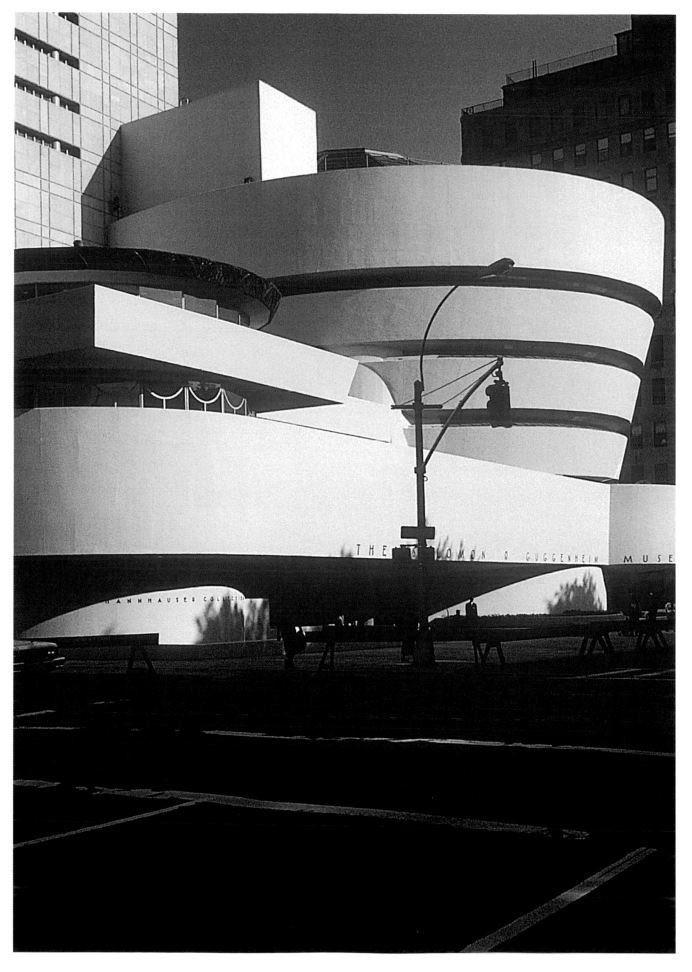

PLATES 66 and 67 below and opposite

Marin County Civic Center, San Raphael, California 1957–66

This extraordinary, expansive, I took and high tensile construction spreads across the land in a way that suggests some science fiction space station. The design was in preparation at the same time as the Greek Orthodox Church (plate 62) considered earlier, and the dome and supporting arches clearly have an affinity with it. The work was not completed until seven years after Wright's death. Its aesthetic credentials are still under some discussion and there is a feeling that the work shows evidence of declining powers, not at all surprising in a nonagenarian. However it is part of Wright's search for what he found lacking in the Usonian works – romance and sentiment in the service of a developing society, unattainable at the time; but it is more than possible that this and other fantasy projects of the twenties will become tentative blueprints for the future.

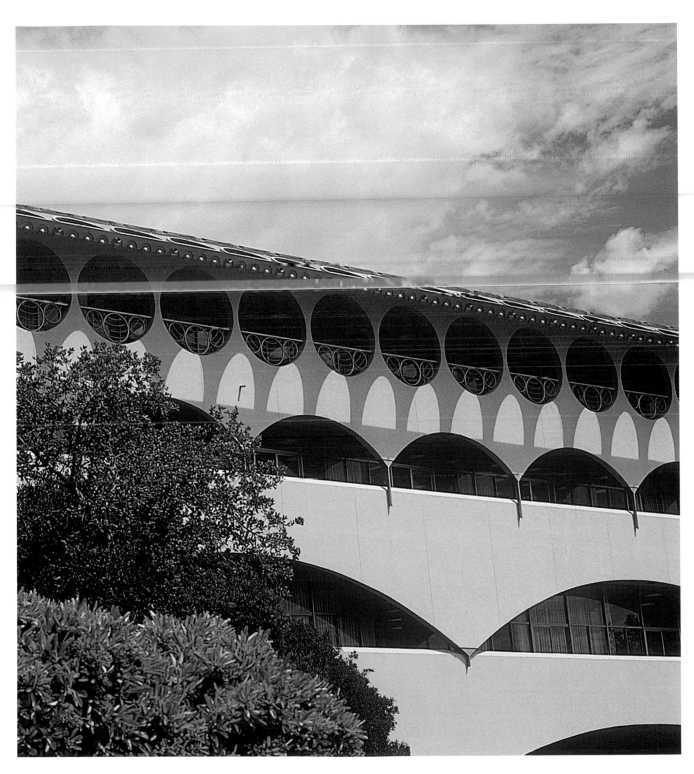

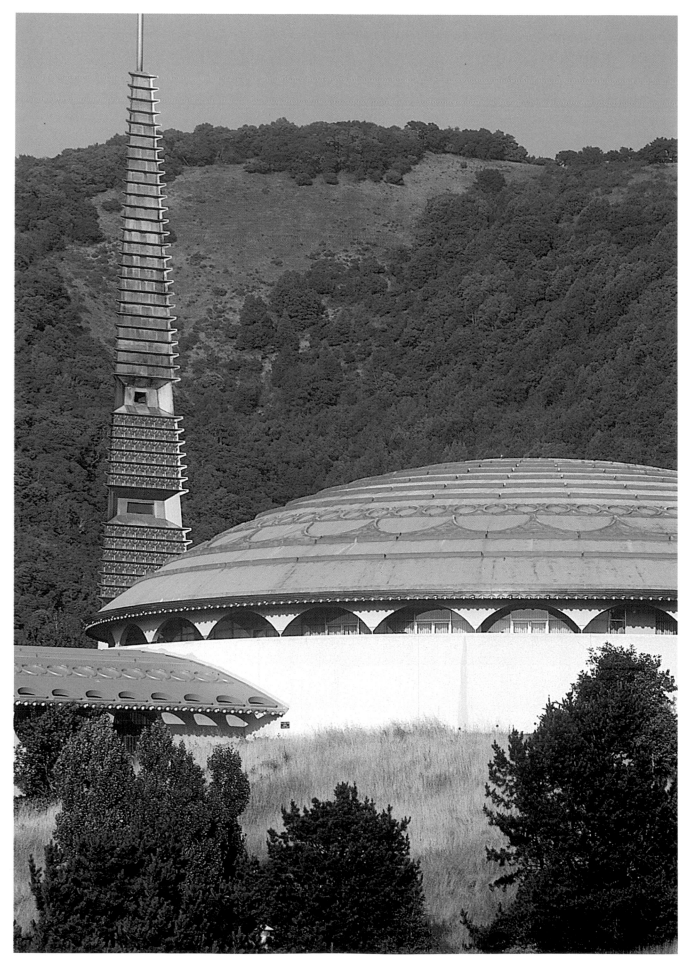

The Publishers wish to thank the following for providing photographs and for permission to reproduce copyright material. While every effort has been made to trace and acknowledge copyright-holders, we wish to apologise should any omissions have been made.

Frank Lloyd Wright studio plaque (page 10)
Thomas A. Heinz (Courtesy Oak Park Public Library)
Frank Lloyd Wright's Own House and Studio (page 11)
Regency House Publishing House Ltd.
Frank Lloyd Wright's Own House and Studio (page 12 above)
Thomas A. Heinz
Frank Lloyd Wright's Own House and Studio (entrance sculpture motif)
page 12 below
Regency House Publishing House Ltd.
Francisco Terrace Apartments (page 13)
Thomas A. Heinz
William H. Winslow House (pages 14 and 15)
Thomas A. Heinz
Walter Gale House (page 16)
Trewin Copplestone
R.P. Parker House (page 18)
Regency House Publishing House Ltd.
W. E. Martin House (page 18)
Regency House Publishing House Ltd.
Frank Thomas House (page 19)
Regency House Publishing House Ltd.
Mrs Thomas Gale House (page 19)
Regency House Publishing House Ltd.
Nathan G. Moore House (page 20)
Trewin Copplestone
Nathan G. Moore House (page 21)
Regency House Publishing House Ltd.
Chauncey L. Williams House (page 23)
Thomas A. Heinz
Arthur Heurtley House (pages 24–25)
Thomas A. Heinz
Ward W. Willetts House (page 26 above and below)
Thomas A. Heinz
William G. Fricke House (page 27)
Thomas A. Heinz
Larkin Company Administration Building (page 29)
Trewin Copplestone
Edwin H. Cheney House (pages 30 and 31)
Thomas A. Heinz
Susan Lawrence Dana House (page 32 above and below)
Thomas A. Heinz
Darwin D. Martin House (page 33)
Thomas A. Heinz
Unity (Universalist) Church (pages 34–35 below)
Thomas A. Heinz

Unity (Universalist) Church (page 35 above left)
Trewin Copplestone
Unity (Universalist) Church (pages 35 above and centre right)
Regency House Publishing House Ltd.
Frederick C. Robie House (pages 36 and 37)
Thomas A. Heinz
Avery Coonley House (pages 38 and 39)
Thomas A. Heinz
Midway Gardens (pages 40 and 41)
Thomas A. Heinz
Imperial Hotel, Tokyo (pages 42 and 43)
Thomas A. Heinz
Aline Barnsdall House (The Hollyhock House) pages 44 and 45
Thomas A. Heinz
Mrs George Madison Millard House (La Miniatura) pages 46 and 47
Thomas A. Heinz
Dr John Storer House (pages 48 and 49)
Thomas A. Heinz
Charles Ennis House (pages 50 and 51)
Thomas A. Heinz
Taliesin III (pages 52 and 53)
Thomas A. Heinz
Edgar J. Kaufmann Snr. House (Falling Water) pages 54–55, 56 and 57
Thomas A. Heinz
S.C. Johnson & Son Administration Building (Johnson Wax) pages 58 and 59
Thomas A. Heinz
Herbert F. Johnson House (Wingspread) page 60
Thomas A. Heinz
Paul R. Hanna House (The Honeycomb House) page 61
Thomas A. Heinz
Taliesin West (pages 62–63)
Thomas A. Heinz
Katherine Winkler and Alma Goetsch House (page 64 above)
Thomas A. Heinz
Lloyd Lewis House (pages 64–65 below)
Thomas A. Heinz
Herbert Jacobs House II (pages 66–67)
Thomas A. Heinz
Unitarian Church (page 68)
Thomas A. Heinz
Beth Sholom Synagogue (page 69)
Thomas A. Heinz
Annunciation Greek Orthodox Church (page 70)
Thomas A. Heinz
Harold C. Price Company Tower (page 71)
Thomas A. Heinz
Solomon R. Guggenheim Museum (pages 72 and 73)
Thomas A. Heinz
Marin County Civic Center (pages 74 and 75)
Thomas A. Heinz

AUTHOR'S NOTE:

A number of sources have inevitably been used in the construction of this book. It is impossible even to recall many of them over a period of reading of some years. Where opinions have been specifically quoted they are acknowledged. Two obvious sources are particularly recommended for further study – and enjoyment. The first is Wright's own *An Autobiography*, a little prolix in the later edition but fascinating reading, and the second, the important study of Wright's *oeuvre* up to 1941 by Henry-Russell Hitchcock, *In the Nature of Materials*. There is, however, a vast library of books and articles on Wright and in addition there is much to be found in the histories of architecture during the last century-and-a-half which place Wright in context with his peers.

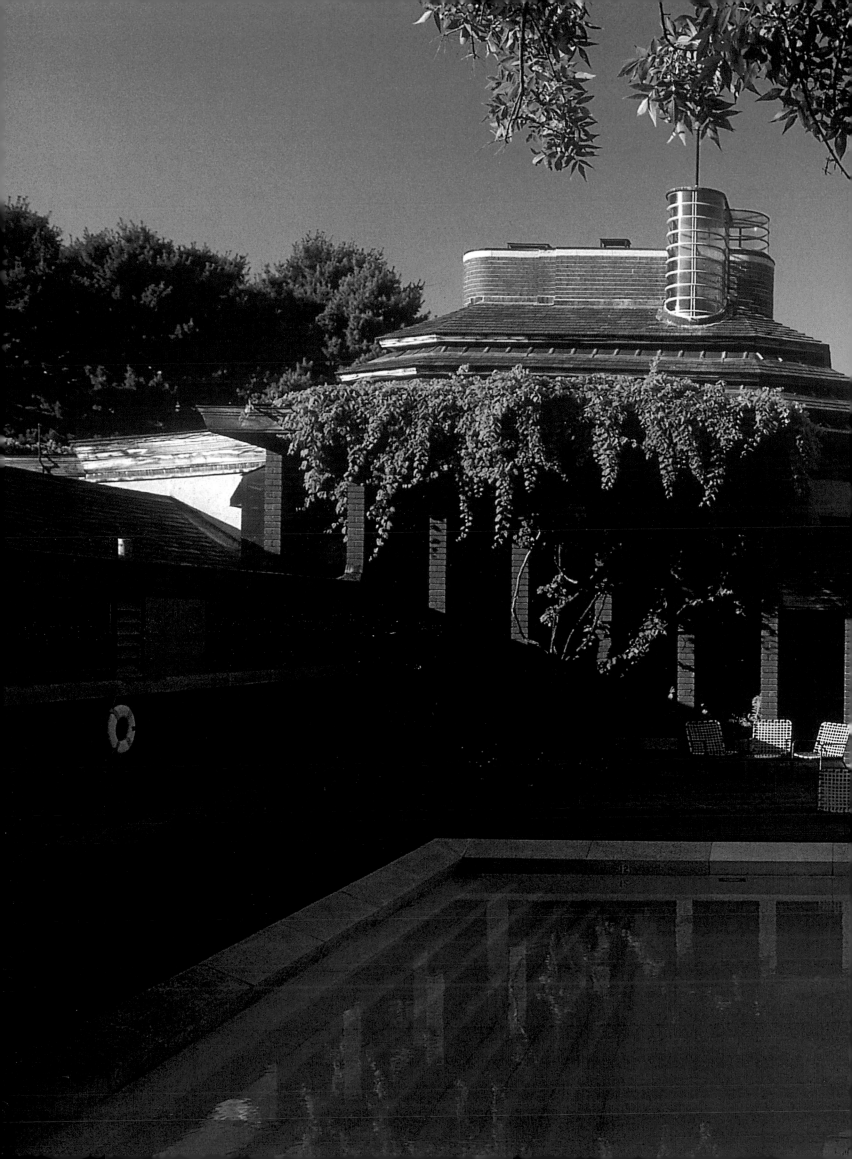

Frank Lloyd
Wright